PORTRAITS
CHARACTER

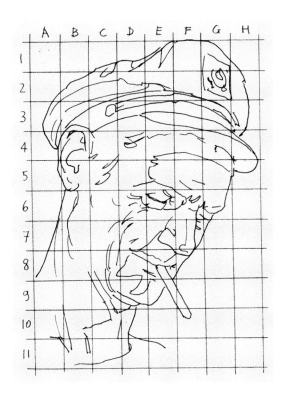

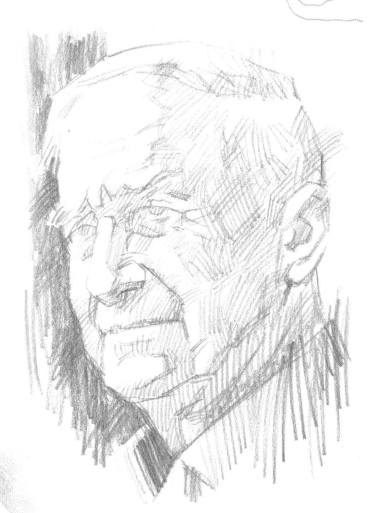

Giovanni Civardi

SEARCH PRESS

Giovanni Guglielmo Civardi was born in Milan on the 22nd of July 1947. With a degree in Economics, he later attended the Faculty of Medicine and the School of Nudes at the Accademia di Brera, dedicating himself to portraits and sculpture. He drew illustrations for newspapers, magazines and book covers for over a decade. He organised personal sculpture exhibitions and furthered his studies of anatomy during frequent stays in France and Denmark. For many years, he has held courses on anatomy and figure drawing, condensing his teaching experience into several books that have been republished several times, many of which have been translated into several languages.

His *Taccuino di Lourdes*, the most recent of his travel notebooks, was written in 2011. He currently lives and works in Milan and Nice. Since 2014, some of his live drawing notebooks and the original drawings for many of his books have been kept at the historical fund in the Accademia di Brera's library in Milan.

All human beings are equal, but it is each person's qualities that distinguishes them.

The situation is clear: all too often, what I like others don't like and what others like I don't like. That's fine.

Simple and expressive. Giuseppe Verdi

A gift is such if accepted, otherwise it is merely scattered dust ready to fly away...

The drawings reproduced in this book are from consenting models and have been authorised by family leaders, who I would like to heartily thank. Any similarity with other people or other children is purely coincidental. In any case, for obvious reasons of confidentiality regarding identification, I have deliberately altered facial features a little to alter true facial likeness. G.C.

Contents

First published in Great Britain 2018 by Search Press Limited, Wellwood, North Farm Road, Tunbridge Wells, Kent TN2 3DR

Reprinted 2019

Originally published in Italy 2016 by Il Castello Collane Techniche, Milano as *Modelli per Disegnare con Griglia: Volti caratteristici*

Copyright © Il Castello S.r.l., via Milano 73/75, 20010 Cornaredo (Milano) Italy

English Translation by Burravoe Translation Services

ISBN 978-1-78221-531-8

If you have difficulty in obtaining any of the materials and equipment mentioned in this book, then please visit the Search Press website for details of suppliers: www.searchpress.com

Introduction

The face is the part of the body that is most exposed to view, and which therefore usually appears familiar and natural. The best way to capture the character in a portrait is to understand the particular shapes and features that make up the individual face.

As with other observation-based techniques, the overall form of the face is studied first, and then the individual physiognomic traits comprising it are analysed; examining the structure, position, proportions and the effects of lighting. It is possible to emphasise the facial features of a head (making it a caricature) but before going down this route, it is necessary to fully understand and express the objective, real shape.

Even by limiting oneself to observing those who we happen to meet, it is easy to be attracted (from an aesthetic point of view) by heads, expressions, faces that have a suggestive structure for the artist. These are the ones that can be called 'characterful'. In such faces, it is easier to capture such a person's personality and life story at first glance than in other faces: the results of the individual's path through life, almost always expressed by the complexity of light and shade – chiaroscuro – and the physical richness that marks and cuts through their faces, heads and souls.

This explains the preference that many artists have not only for the attitude but also for the lived-in faces of elderly people in whom life has left clear traces of an 'existential story'. The connection between the external appearance and psychological or moral character, between the person and the social environment, has been studied since ancient times, converging into the codes of physiognomy and more recently, of morphopsychology.

Many artists have used models whose faces could symbolically represent the physical and psychological characteristics that were closest to the protagonists of their historical, mythological or religious paintings. This was common in the seventeenth and eighteenth centuries, but is fundamentally no different from what happens today when theatrical or cinema actors are chosen as their physical appearance is suited to the characters they play.

In this book, I have collected a series of heads – drawings that could be used as preparatory studies or be purely aesthetic, autonomous in meaning – that I have drawn live or from photographs after being attracted by some characterful features in the faces.

There are many paths of artistic experience: in drawing these faces, I chose to stay within the boundaries of figurative tradition: searching solely for a frank, descriptive translation of the forms instead of offering more personal, 'artistic' interpretive styles. This leaves those who wish to practise drawing full liberty in elaborating on the basic physiognomy. In short, these pictures intended to be used to stimulate the artist's interest, and encourage you to search for other subjects in the environment you live in or visit.

Although photography is invaluable for capturing fleeting expressions, unusual or random gestures, and unrepeatable situations, It is best to proceed with the portrait from life where time and practicality make it possible: there is a substantial difference between reality as seen and its photographic reproduction, if for nothing else than the lack of spatial depth. Reality gives us the model in its three spatial dimensions, while photographic reproduction mechanically transforms space into a two-dimensional surface, similar to the one on which an illustrator or painter works upon. When starting to draw, using a grid can aid the conceptual changeover between reality and the simplification suggested by the flat image, helping the artist to express volume.

I hope that the ancient procedure of drawing a grid, or mesh (see page 13) is used as an initial *viaticum* or temporary support to help lay the technical bases – observation, proportion, shading and so forth – from which to proceed with the portrait and elaborate the most significant expressive style (as in the end, all faces are 'characterful').

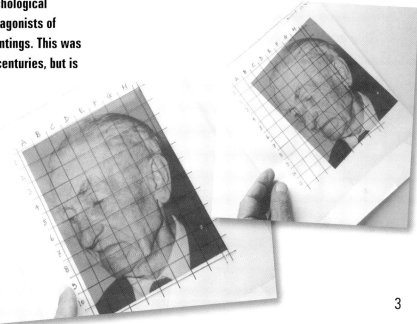

Anatomy

When we look at a living person, the bone structure of the head appears in direct, immediate ratio to the external forms as the 'soft tissues' — the muscles, skin and subcutaneous tissues and so forth — faithfully cover the surface, only increasing and adding to it to various degrees.

BONE AND ARTICULAR STRUCTURE

The skull, in a broad sense, has two parts: the cranium (braincase), which is ovoid in shape; and the facial block that houses some of the sensory organs (eyes, nose) along with the start of the digestive and respiratory routes, which is a pyramid shape. The bones are almost all joined to each other with continuity joints that do not allow movement. The only mobile bone is the mandible, that moves within the limits permitted by the temporomandibular joint.

MUSCULAR STRUCTURE

There are two types of muscles that cover the skull: the mimetic muscles, which allow facial expressions and are connected with the skin, mainly spread over the facial block; and the masticatory muscles, which dictate the mobility of the jaw (temporal muscle, masseter muscle, pterygoid muscles and so forth). Many neck muscles are connected to the base of the skull and are used to rotate, flex or extend the head. A thin, long muscle (the platysma) runs under the skin of the neck and works on the jaw, lowering it.

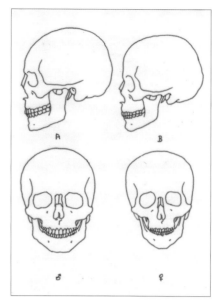

Side view and front view of a typical male adult skull (A) and a typical female skull (B).

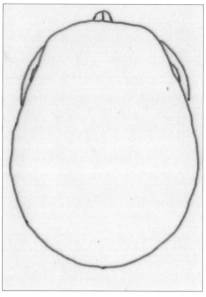

View of the skullcap in a zenithal projection: note that the width of the frontal lobe is smaller than the occipital lobe.

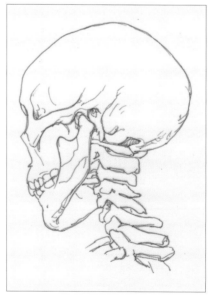

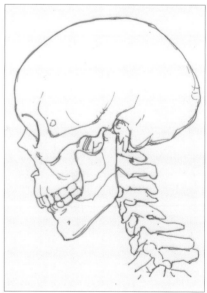

The skull in an oblique-posterior (above left) and lateral (above right) projection. It is joined with the cervical part of the spine, which is the support axis for the muscles running along the neck. The sum of the movements allowed by each vertebral joint contributes to the extension, flexion, and lateral extension and flexion of the head.

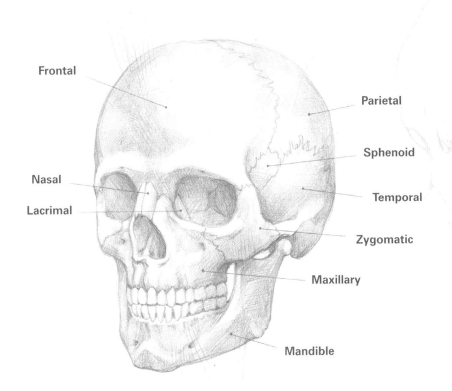

Frontal

Parietal

Sphenoid

Temporal

Nasal

Lacrimal

Zygomatic

Maxillary

Mandible

Oblique-frontal projection of the skull in toto, with an indication of the bones that determine the outer appearance.

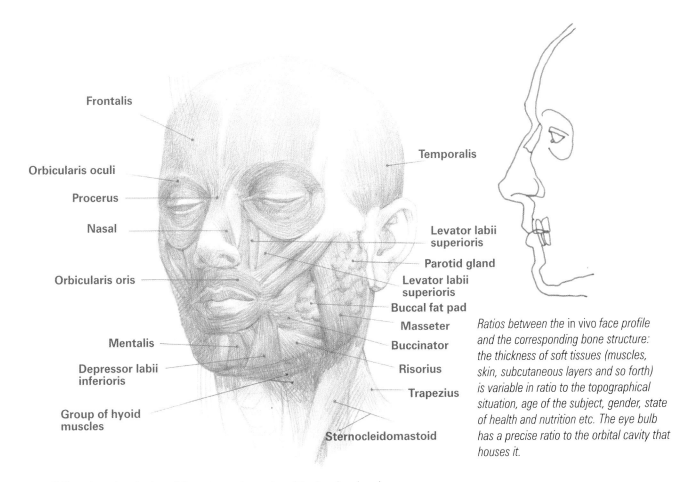

Frontalis

Temporalis

Orbicularis oculi

Procerus

Nasal

Levator labii
superioris

Parotid gland

Orbicularis oris

Levator labii
superioris

Buccal fat pad

Masseter

Mentalis

Buccinator

Depressor labii
inferioris

Risorius

Trapezius

Group of hyoid
muscles

Sternocleidomastoid

Ratios between the in vivo face profile and the corresponding bone structure: the thickness of soft tissues (muscles, skin, subcutaneous layers and so forth) is variable in ratio to the topographical situation, age of the subject, gender, state of health and nutrition etc. The eye bulb has a precise ratio to the orbital cavity that houses it.

Oblique-frontal projection of the outermost muscles of the head and neck.

Features and proportions

A face is considered 'characterful' when it immediately and markedly shows the physiognomic traits that describe the personality, peculiarities of behaviour and expression in a person. The features become interesting for the artist ('plastically interesting', we might say), both individually and as parts of a whole, as they lead to a marked individual expressiveness. This is founded upon the shape and anatomical characteristics of the main areas of the face – eyes, nose, and so forth – declined according to the appearance that they take on in relation to the subject's gender, age or human group.

THE LIPS

Commonly expressed by their extended pink-hued portion, lips follow the curve of the dental arches to which they are attached. The upper lip has a more defined, complex shape than the lower lip, which is more rounded.

Lips are extremely mobile and assume very different extensions and protrusions depending on the expression and action being taken.

Some elements of shape and structure that should be considered to help draw a convincing portrayal are provided in the diagram.

1 – philtrum; 2 – tubercle; 3 – vermilion border; 4 – mentolabial sulcus; 5 – lower lip; 6 – labial commissure; 7 – upper lip.

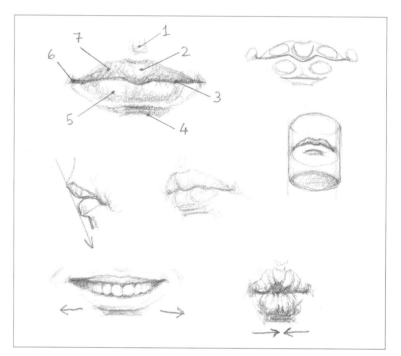

THE EAR

These are the external parts of the hearing organ and are placed next to the acoustic meatus in a precise position, just behind the temporomandibular joint.

Ears are largely made up of cartilage (the twists and turns of which describe the characteristic 'shell' shape) and of a small portion of softer, fleshy tissue (the lobe).

Although all people share the same underlying structure, the outer ear can vary greatly in size and shape between individuals.

1 – (Darwin's) tubercle; 2 – helix; 3 – anti-helix; 4 – antitragus; 5 – lobule; 6 – tragus; 7 – triangular fossa (navicular); 8 – concha.

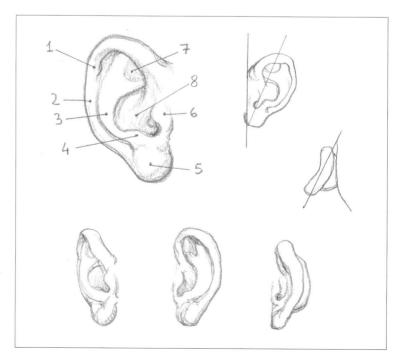

THE EYES

The eyes are spherical. Each is contained in its own orbital cavity in the skull that offers both mechanical protection and possibility of movement, led by the fine ocular muscles.

The shape of the ocular region can differ according to the age, health or ethnic group to which the subject belongs, but in all cases the external appearance is dominated by the circular, concentric presence of the iris and pupil; by the eyelashes and eyebrows; and by the eyelids. The upper eyelid is extremely mobile, while the lower eyelid is more stable, thinner and smaller.

Drawing eyes requires special attention, as it represents the most evident and significant feature of physiognomic expression: the reflections of light on the shiny, humid surface of the eye must be placed in the right position and with the right intensity; while eyelashes and eyebrows must be treated as fine, delicate, soft masses, rather than with detailed, analytical indications of each hair.

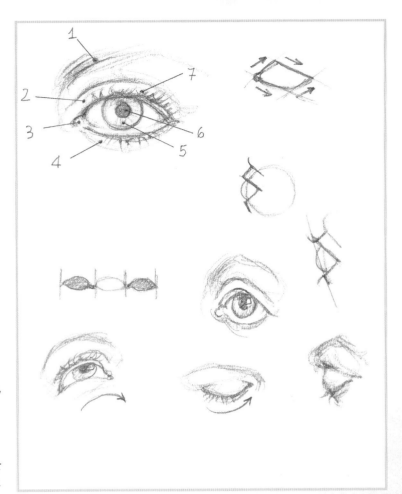

1 – eyebrow; 2 – upper lid; 3 – lacrimal caruncle; 4 – lower lid; 5 – iris; 6 – pupil; 7 – eyelashes.

THE NOSE

The nose is a pyramidal shape and is located at the centre of the facial block, along the median line. It comprises a narrow and solid bone portion in the upper part; and a soft and protruding cartilaginous portion in the lower part, around the nostrils and the lobule.

When drawing the nose, it is advisable to consider the difference in consistency of the tissues involved, in order to portray it effectively.

The profile of the ridge varies a great deal (from straight to very curved) depending on the individual's age and ethnic group.

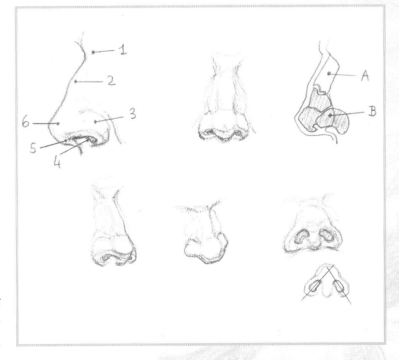

1 – root; 2 – ridge; 3 – wing; 4 – nostril; 5 – subseptum; 6 – lobule.

A – nasal bones; B – nasal cartilage.

Note

The descriptions here are intended to act as an overview of the morphology of the human face, and are primarily aimed at stimulating the artist's observational capacities.

HAIR AND BEARD

From an anatomical point of view, hair on the head and face can be considered secondary facial elements, but from an aesthetic point of view they are extremely relevant. Hair type and style contributes to characterising the individual and showing the ethnic, biological, social and cultural group to which he or she belongs.

When drawing this part of the head, it is advisable to consider the line, colour, volume and direction of the main locks. In fact, it is useful to consider these shapes as sets of small masses rather than single hairs. Hint at, rather than describe, the effects of depth, chiaroscuro and volume on these masses.

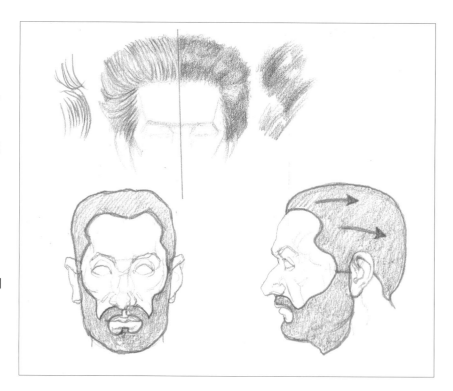

SOME EFFECTS OF AGE

Faces almost always develop character and interest for the artist as the subject ages, in relation to his or her lifestyle or profession. These changes and adaptations mainly affect the skin, creating contrasts of volume, shadows, lines and intersections of grooves on the face, which are extremely attractive and effective for suggesting character in a drawing.

There are many well-known examples. Wrinkles – the folds and channels in skin caused by loss of elasticity and habitual expressions – produce alternating chiaroscuro tones and direction of lines, that are graphically rather effective. They usually appear on the forehead, around the eyelids, on the side of the nose, on lips and on the neck.

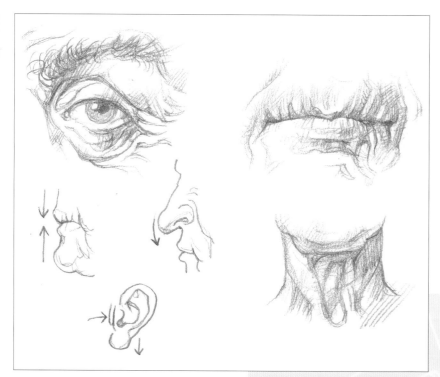

Nose cartilage alters in volume and consistency, causing the lobe to lengthen and droop. Earlobes also become longer and one or two vertical lines appear near the tragus. Other, less immediately noticeable changes occur, of which we are all aware. These include the consistency and colour of hair; the appearance of small, dark age spots on the face; the adaptation of lips to dentures and many more.

THE PROPORTIONS

The human head varies considerably in size and proportion in each subject (and also varies according to the stage of growth), which is what allows us to recognise an individual. When drawing a face, however, it is important to search for elements beyond these, and bear in mind the unchanging ratios of the head.

Each head follows a structural plan and spatial ratio between the individual elements that comprise it. When we draw a head (whether generic or individual) therefore, we must take the following into consideration:

- A head has an overall ovoid shape and therefore constitutes a volume.

- The head's components are arranged symmetrically along the median axis.

- In oblique views, or from top or bottom, the linear perspective helps in the three-dimensional representation of the head *in toto*.

- Facial elements are arranged according to constant proportional ratios that are applicable roughly to all adults.

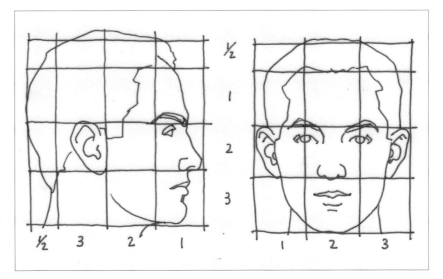

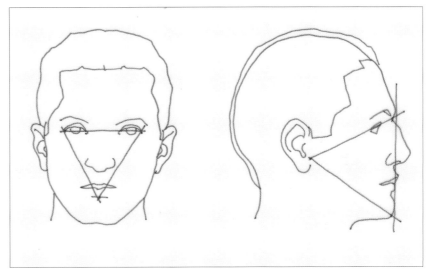

These simplified diagrams are useful for evaluating proportional ratios for drawing 'generic' heads and when drawing an actual subject's portrait. Careful observation should be enough to grasp the main ratios, having seen the lateral and front projections. For example, it is simple to ascertain that the height of the face (from the root of the hair to the chin) can be divided into three sectors of approximately the same height, outlined by four horizontal lines placed at the root of the hair, at the top of the eyebrows, at the base of the nose and at the bottom of the chin; or, that the position of the outer ear and that of the main elements of the face are guided by the tips of an equilateral triangle.

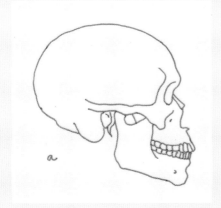 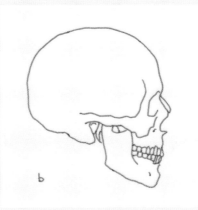 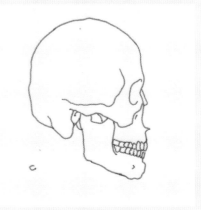

Diagrams of skull profiles from individuals belonging to different anthropological groups: a) negroid, b) caucasoid, c) mongoloid.

Approaches to drawing

Drawing is a tool for learning to see – both literally, in the case of what is around us, and metaphorically, in what arises from our projects and our emotions. Through drawing we can decide to gather information about a visual situation or extract the most important, expressive elements from the situation. At root, the character and qualities of a form are more important than the simple superficial method by which it is expressed. The various drawing techniques are chosen and used to translate these aspects in the most interesting, effective graphic manner.

Only two of the most simple, traditional approaches are referred to here: linear and tonal. Either can be applied in a pure form or they can be combined and integrated with each other and conveyed into a third, mixed approach.

As a subject, the human face is extremely well-suited to experimenting along these paths of drawing and expression, as the artist searches for what he or she finds most stimulating or most suited to their aesthetic style and the formal characteristics of the model.

When drawing 'characterful' faces, it is advisable to reflect a while on the modes and results of visual perception. For example, from the first weeks of its life, a new-born baby is attracted to and learns to recognise the typical shape of a human face: simplified to an oval with a regular, constant relation, and marks that suggest two eyes, a nose, and a mouth. Similarly, many right-handed people, regardless of cultural background, tend to 'read' the image from left to right, while others have the opposite preferential perception of our visual centre of interest.

The approaches shown here are only some of the many methods possible, of course: Once you have drawn the basic shape and structure lines with the help of grids, you can continue by using your technique and style freely.

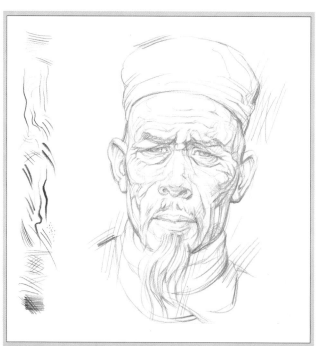

LINEAR

With this approach, tone becomes subordinate to line, or is missing entirely: line defines the shape.

Line does not exist in nature, but it is the oldest, most intuitive graphic convention to define the shape of an object through its overall outline and the outline of each element that is a part of it.

The line can be thin and even or modulated, thick, angled, interrupted, crossed or thickened, and used in relation to the effect of a tonal weave that the artist wishes to suggest.

The linear procedure refers to the way of using drawing tools and is independent from them, although some are more suitable than others: hard graphite, nib and ink, and felt tip pens are particularly well-suited.

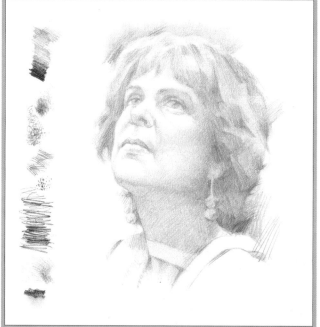

TONAL

Here, the line is subordinate to tone or is missing: tone describes the shape.

Tone is the degree of shade that distinguishes the light, illuminated areas of an object from the dark ones, in shadow. The range of monochrome shade is achieved in chiaroscuro. The most suitable tools are the ones that lend themselves to a 'pictorial' portrayal of the portrait, such as soft graphite, charcoal, and watercolour.

See page 26 for a comparison of linear and tonal procedures applied to the same subject.

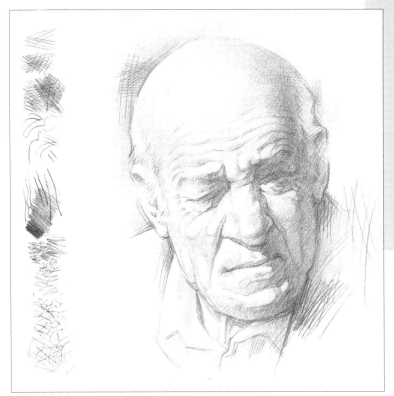

MIXED

Integration between line and tone. This is the most intuitive and traditional procedure, often used in realistic portraits. Both line and tone are brought together to define the shapes and volumes of the face and to express the chiaroscuro effects.

With this approach, each artists can find full freedom of style and choice, through the use of varied tools and traces.

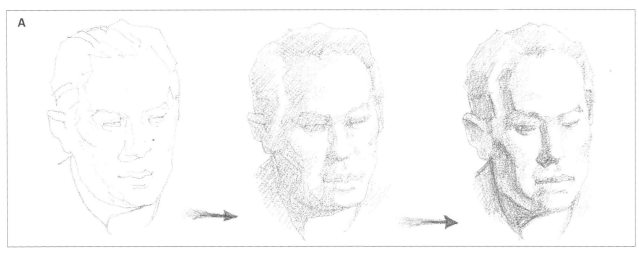

A

There are different ways to draw a portrait – different 'paths of creation'. The artist's psychological and stylistic approach, might, for example, lead them through searching for a 'rational' construction of the shapes. Alternatively, the artist might prefer an emotional, abbreviated path.

Figure A, above, shows the steps of an analytical way of working (during which the form and shape is gradually developed – see page 12): linear structure on the left, followed by the addition of the main tones of shade in the centre, followed in turn by modulation of the chiaroscuro for the finished image on the right. In combination with a grid, this is the procedure I followed for almost all the portraits shown in the 'Gallery of faces' chapter of this book.

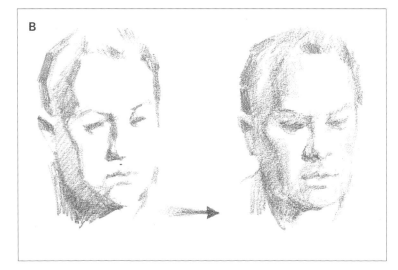

B

Figure B shows an alternative way of working: the development stages of a portrait based solely on the play of tones (see pages 12 and 24). Indications of only the main shade area are on the left of the image, while the right-hand side shows elaboration of the intermediate tones and 'accents' to complete the drawing.

The approaches referred to on the two previous pages can lead to very different graphic results. These are not a direct result of the use of a particular technique, but will vary according to the artist's expressive aims and aesthetic choices, and the visual perception of shapes by the artist. These choices lead the artist to portray what they are seeing in different ways.

A **synthetic portrayal**, as in the example to the right, leads to an 'abbreviated' drawing, we might say – although not an approximate one. Such a portrayal concentrates on elements of tone and shape chosen as being essential and sufficient for an effective, suggestive, and evocative portrayal of a head. It is therefore an approach that requires a capacity to make a summary observation of the main parts, and an ability to clean the drawing of secondary detail in favour of a strong, expressive character.

An **analytical portrayal**, in contrast, produces a clear, detailed, and faithfully described drawing that incorporates all the details of structure, shape and chiaroscuro of the head. The final shape is obtained by layering increasingly precise details that are connected to each other. It is therefore a gradual, structured drawing that requires good analysis and attention to detail and a lot of patience in execution.

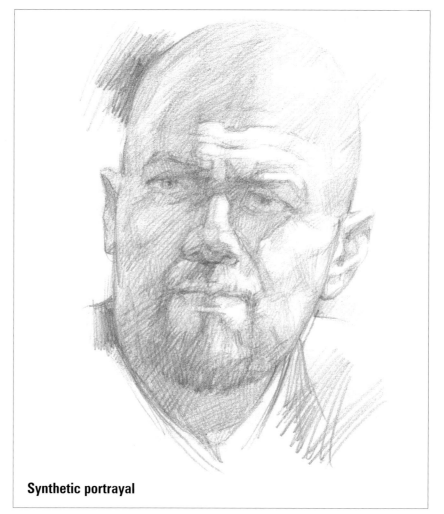

Synthetic portrayal

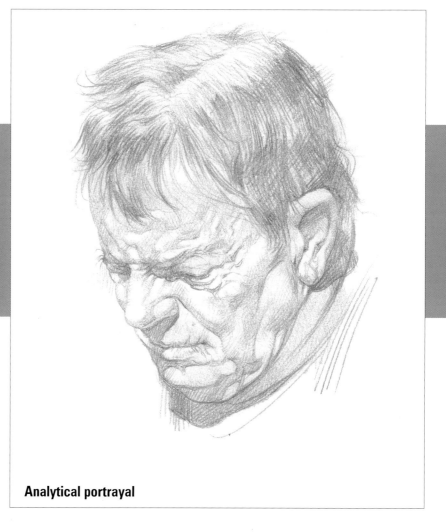

Analytical portrayal

USING THE GRID

Of the many 'mechanical' approaches – which includes photocopying, projection, photographic and digital zooming – that can be used to reproduce a flat reference picture (whether drawing or photograph), that of using the grid is the simplest and oldest method and the one that most respects the honest practices of the manual skill of painting. It is also the one that provides both great precision and full freedom of execution and development when completing the following steps.

The procedure is a simple and intuitive one: a number of orthogonal lines – that is, horizontal and vertical – are drawn directly (or on tracing paper) onto the reference picture to form a grid of evenly-sized squares. A similar grid is then traced onto a drawing support (e.g. a sheet of paper, board, or canvas) using light pencil lines. The outline segments of the subject can then be copied from each square on the reference picture to the corresponding square on the grid on the drawing support, until all the outlines have been completed. Before completing the new picture with freer procedures (see pages 14–15), I recommend you erase the grid lines.

Depending on the desired result, you can vary this technique. Using more squares on the reference grid will give you less to copy from each square, making things more precise – though at the cost of having more individual squares to copy. The size of the squares on the support can vary from those on the reference picture in order to obtain a larger (or smaller) grid.

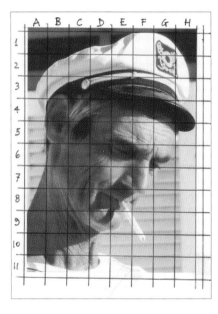
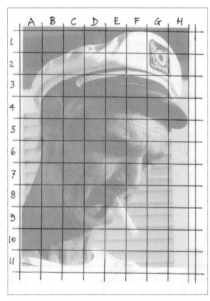

Grids drawn directly onto a photograph or drawing (left) and on tracing paper (right) over a photocopy.

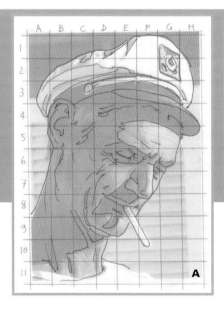
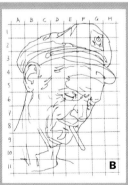
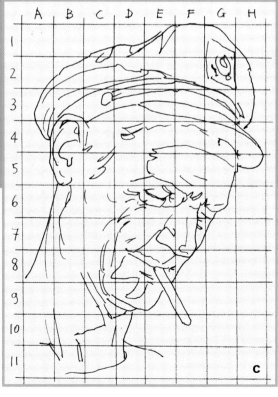

Here, figure A shows the synthetic outline of the main shapes and outlines. Figure B shows these reproduced on a smaller grid, for a reduction in size; while Figure C shows them reproduced on a larger grid. The numerical and alphabetical sequences placed at the sides of the grid are useful for helping to find the single squares.

THE DEDUCTIVE AND INDUCTIVE PATHS

Earlier I mentioned some traditional approaches to drawing. For the most part, the portraits in this book have been produced using a deliberate combination of the linear and tonal techniques and according to the 'analytical' procedure of the gradual construction of shapes (see page 11). This combination can be broken down into two different parts: observing and reproducing the shapes. There are then two paths to take: deductive – that is, working from the general to the particular; and inductive, where your starting point is the particular, which is then developed into the general.

The deductive sequence – from the general to the particular – is the more traditional one, suggested by most 'academic' schools of art. It is a didactic approach that now appears to be obsolete but that, once learned and interpreted, leads to expertise in the technical tool and therefore in expressive freedom. It proceeds from the 'general' to the 'particular' and the subject of the drawing is evaluated as a whole – that is, the overall outlines are drawn first of all, larger than the shape to be portrayed (Step 1: overall shape and dimensions); then inside these lines, the details in their correct ratios are added (Step 2: proportions); volume elements and tonal areas are then identified (Step 3: planes and structure); and finally the shading of tones, the details, volumetric sizes are inserted (Step 4: volume and tonal modulation).

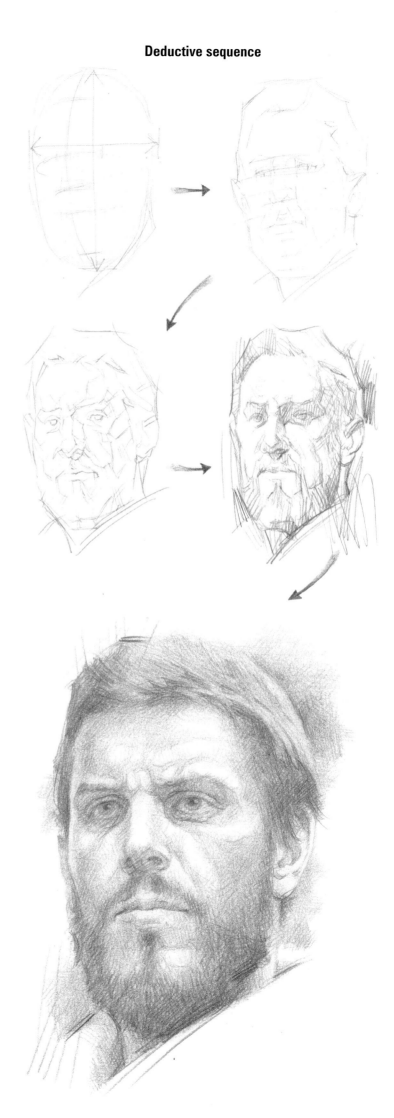

Inductive sequence

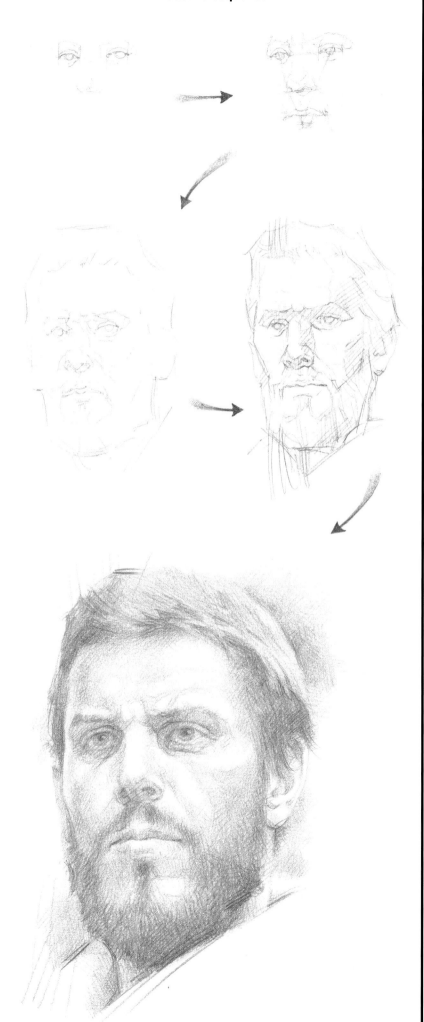

The inductive sequence (from the particular to the general) is more innovative and less restrictive, but also more demanding for the artist as it requires a good level of spatial and proportion ratio awareness.

After an initial evaluation of the area that the subject will occupy on the sheet, a significant detail (usually an eye, when portraying a human face) is chosen as a reference element of measurement and position to which all the other elements will then correlate, in a kind of expansion of shapes up to the outline that surrounds them.

The drawings on this page and the next should be clear enough to describe the main steps to follow in each case. The final result is the same for both paths.

Portrait gallery

The drawings printed in this section (from page 16 to page 77) have been chosen to provide ideas and elements to practise, in order to be able to observe and study the proportions and shapes of a 'characterful' human face.

 The graphic style that I used in drawing them is somewhat 'neutral', which reflects the intention to provide the objective elements of each face, so that the artist wishing to draw it can start from these elements and elaborate his own graphic interpretation, according to the styles and techniques that he believes to be the most suitable and fitting for his own aesthetic awareness and sensitivity.

 Each portrait is accompanied by a rapid preliminary study of the main tones and their connections: they are all drawings created quickly, using very soft lead pencils and a much freer style (almost a sketch or visual note) than the one I then applied to the to the portrait itself.

 The 'grid' is usually drawn on the reference picture that is to be reproduced, but I preferred to use transparent paper and trace only the key facial features onto it – just enough to begin the process of developing the character of the face.

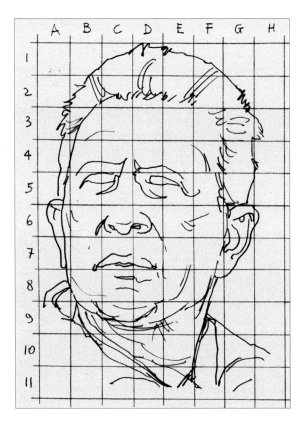

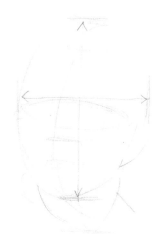

Step 1: Overall shape and size *Step 2: Proportions*

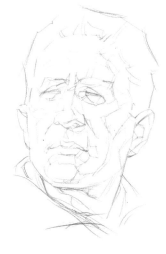

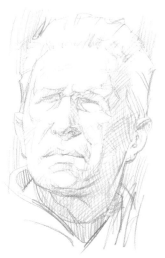

Step 3: Planes and structure *Step 4: Tonal modulation*

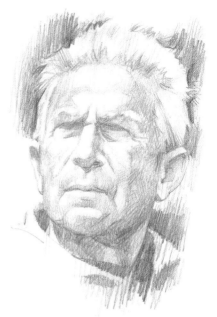

Tonal study

A NOTE ON TECHNIQUE AND METHOD

All the portraits in this section of the book were drawn using HB and B graphite on paper measuring 21 x 28cm (8¼ x 11in).

The tonal studies which accompany the majority of the portraits were drawn using a softer graphite – 4B and 6B – on paper measuring 15 x 21cm (6 x 8¼in).

The grid shown for each portrait can serve as an initial guide to reproduce the basic outlines of the head (after tracing it onto the drawing surface, at the desired size).

After the summary indication of the overall sizes, the next steps for producing the drawing involve controlling proportions, identifying the constructive 'planes' and the modulation of chiaroscuro tones.

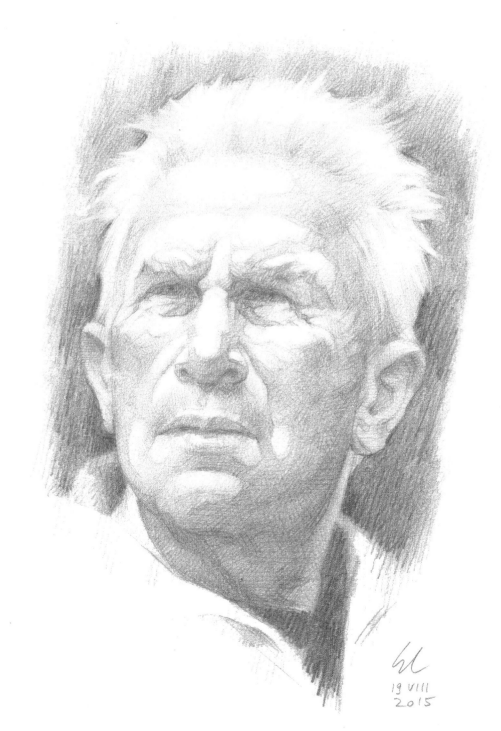

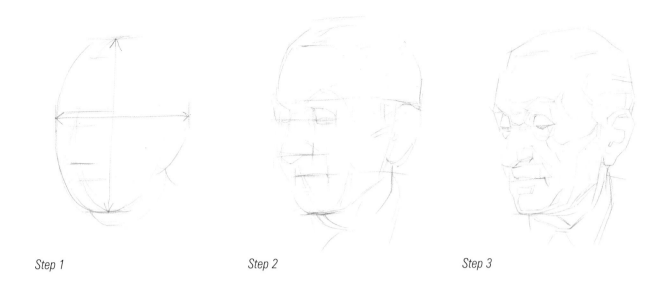

Step 1 Step 2 Step 3

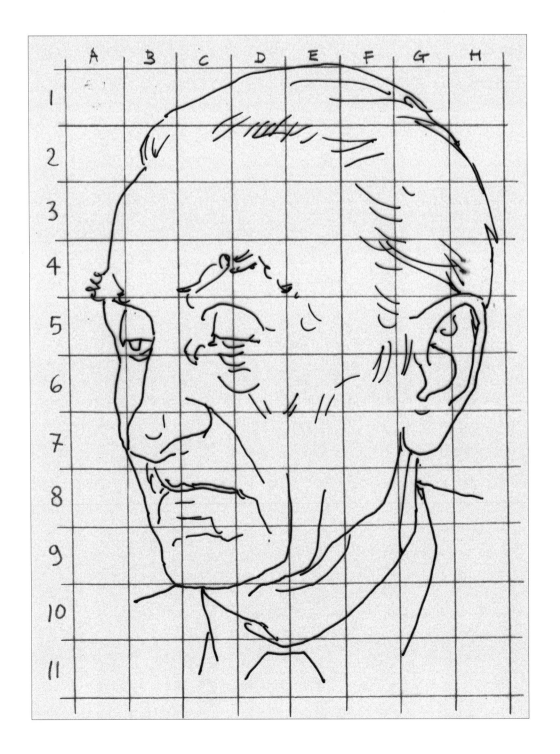

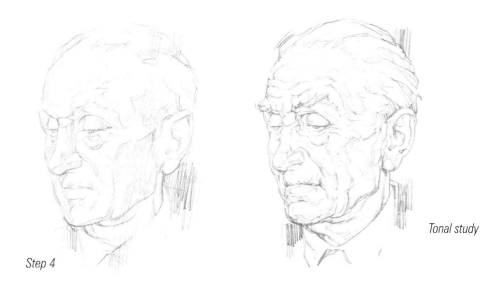

Step 4

Tonal study

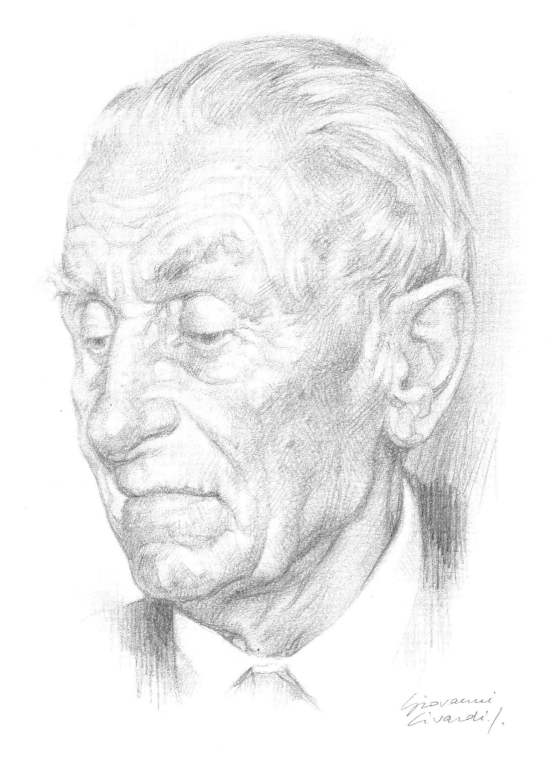

19

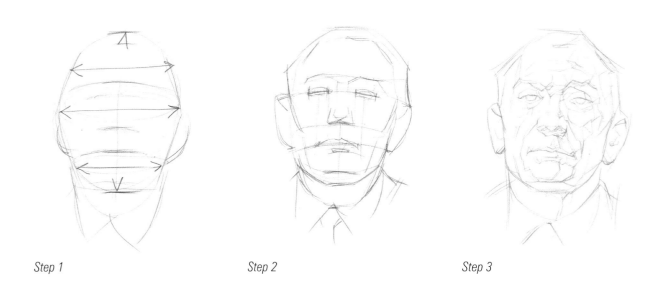

Step 1 *Step 2* *Step 3*

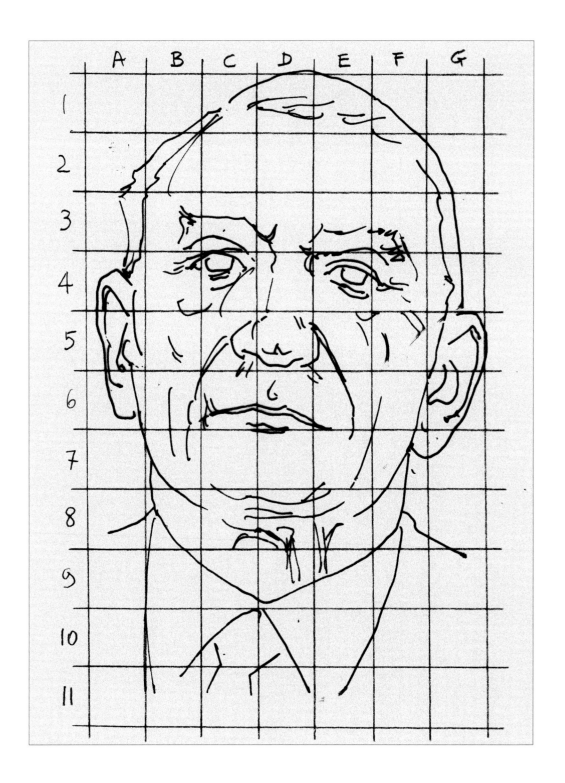

20

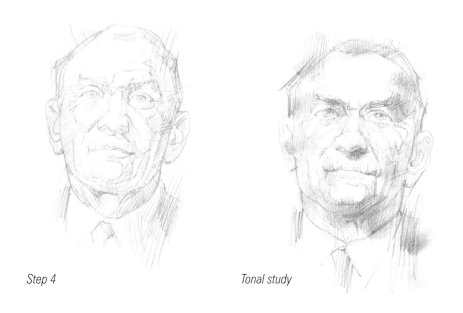

Step 4 Tonal study

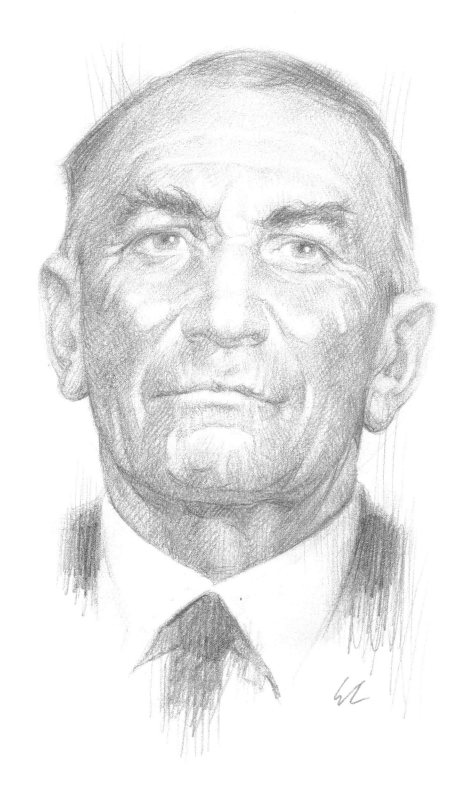

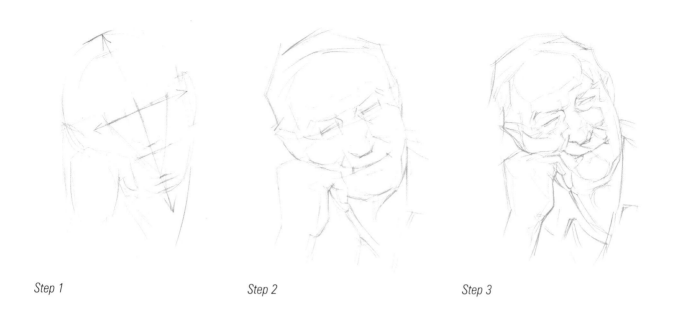

Step 1 Step 2 Step 3

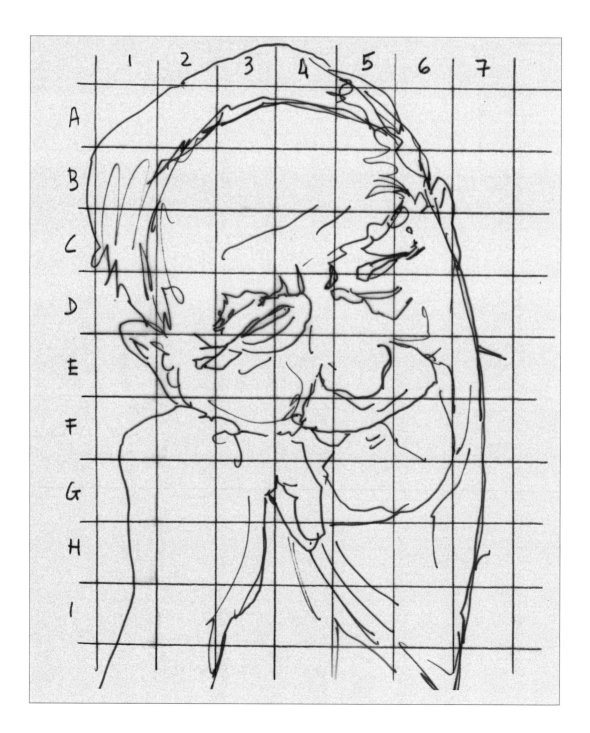

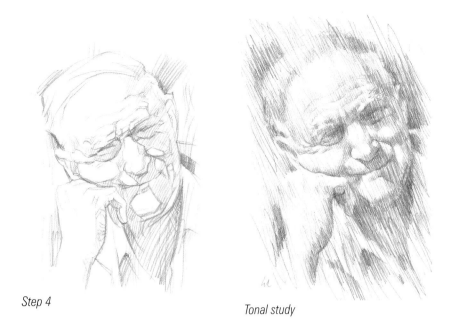

Step 4

Tonal study

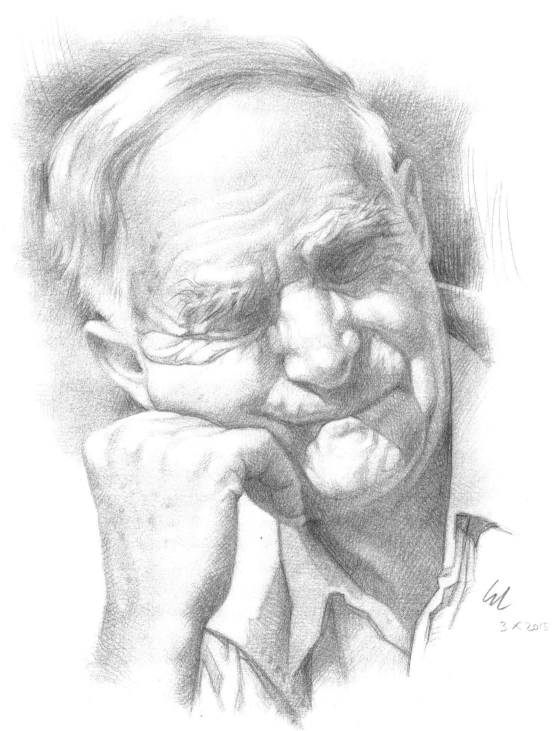

3 X 2015

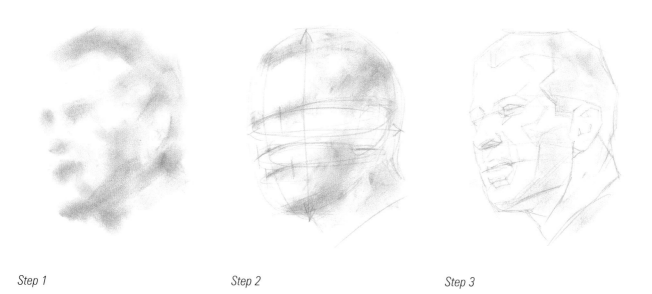

Step 1

Step 2

Step 3

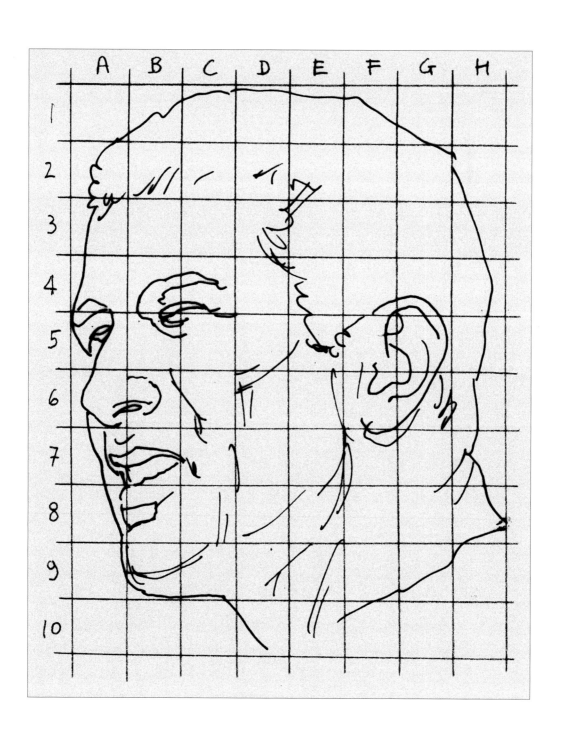

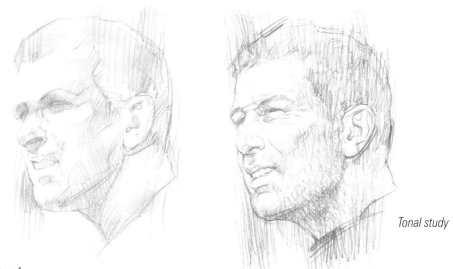

Tonal study

Step 4

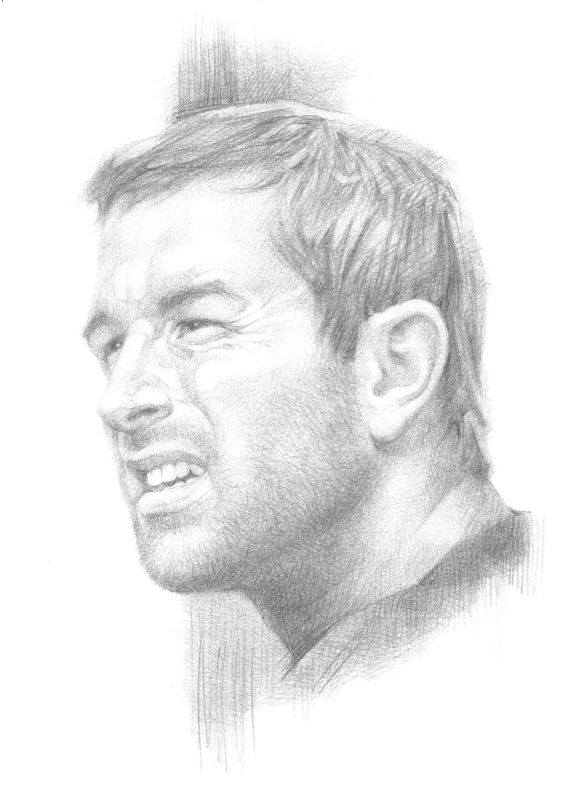

OTHER DRAWING MEDIA

There are many drawing media and there are countless styles with which they can be applied. On the opposite page I have chosen four of the most traditional and well-known media to portray the same face as that reproduced here in pencil, in order to allow for easy comparison.

 While it is true that there are many computer programs that allow you to create amazing drawings directly onto digital tablets, simulating all the graphic and painting techniques, it is without doubt that the physical practise of drawing offers the best guarantees for learning to observe and 'see', and above all to express the most authentic emotive sensitivity...

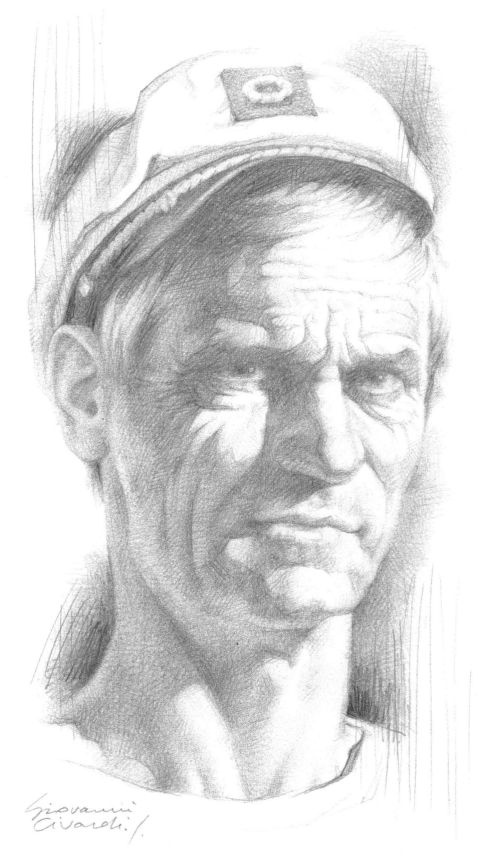

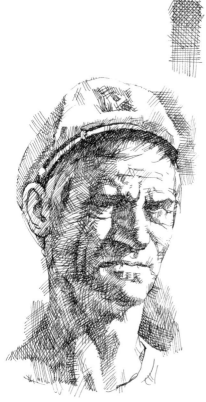

Pen and ink with regular lines

The lines are crossed and of various density to obtain the different gradations of tones. A technique derived from chalcographic etching (known as 'cut and counter-cut') is very effective, produced from lines close to each other or crossing orthogonally or at various angles.

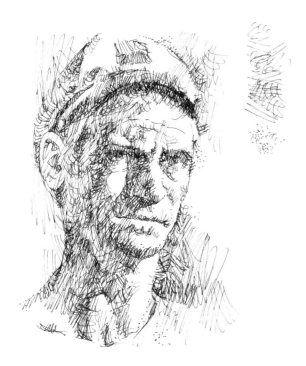

Pen and ink with free lines

The pen's lines in this case are thicker, further apart or cross freely. They appear to be highly irregular. However, the tonal values are gradually reached by making sure that the shadows are not too dense and that the lines, while varied and free, are not too random, thus causing confusion. A preliminary summary pencil drawing can be used as a guide and allow great certainty and spontaneity in the lines.

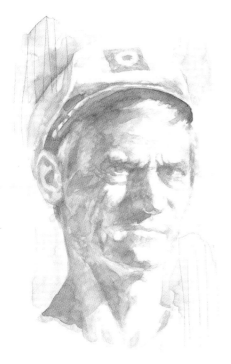

Monochrome watercolour

Using water-soluble graphite is a technique that lies midway between drawing and painting. It produces effects that are somewhat suited to portraits, especially of the sort of characterful face with which this volume is concerned.

Ink can be substituted for watercolour paint, and a very soft bristle brush used to apply it to the surface. An outline drawn with a pencil may help to provide greater consistency to the shapes: it can be left to show through the thin layers of paint, or even be emphasised, in order to hint at spontaneity and structural consistency. The paper must be heavy enough to tolerate the moisture without cockling.

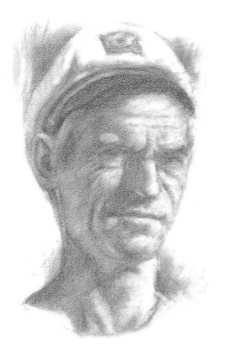

Compressed charcoal

Charcoal offers a wide range of chiaroscuro tones, from the softest to the most intense. It can be blended with the finger or a soft cloth, and can be erased or easily 'lightened'. There are various types, each with its own characteristics: for this study I used a brown coloured Conté pencil.

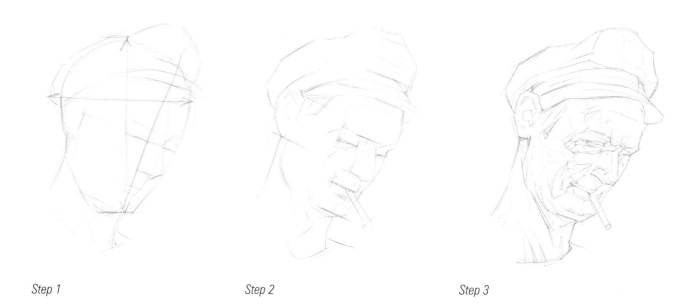

Step 1 *Step 2* *Step 3*

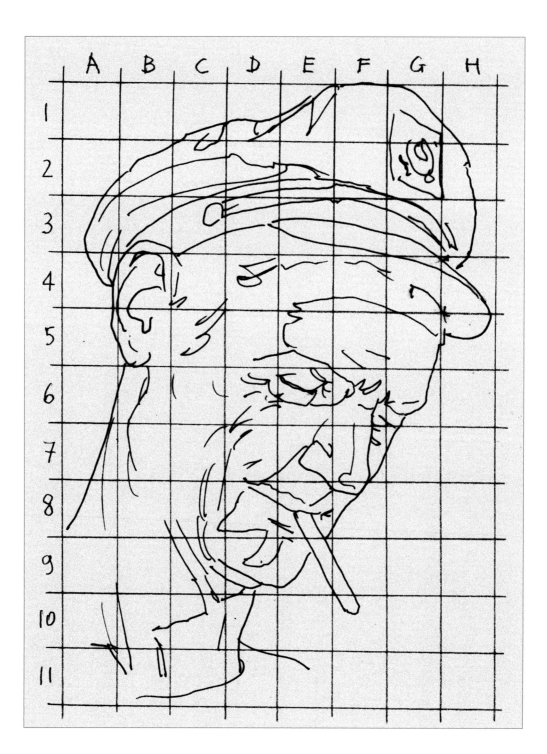

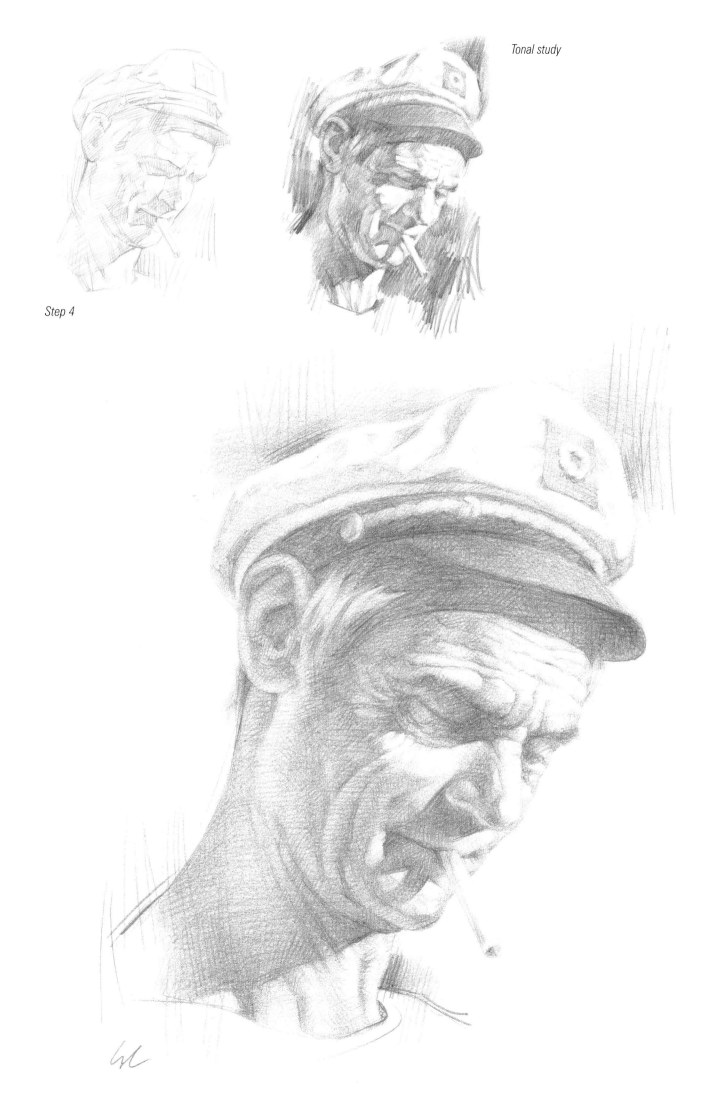

Tonal study

Step 4

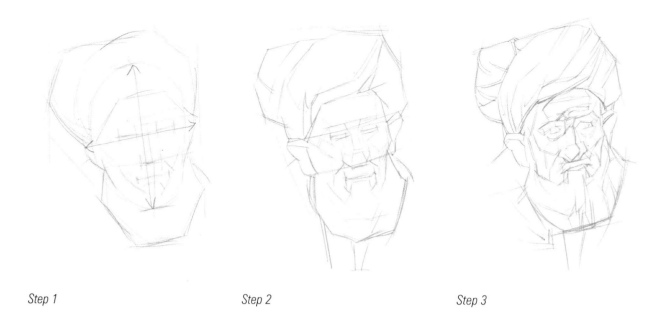

Step 1 Step 2 Step 3

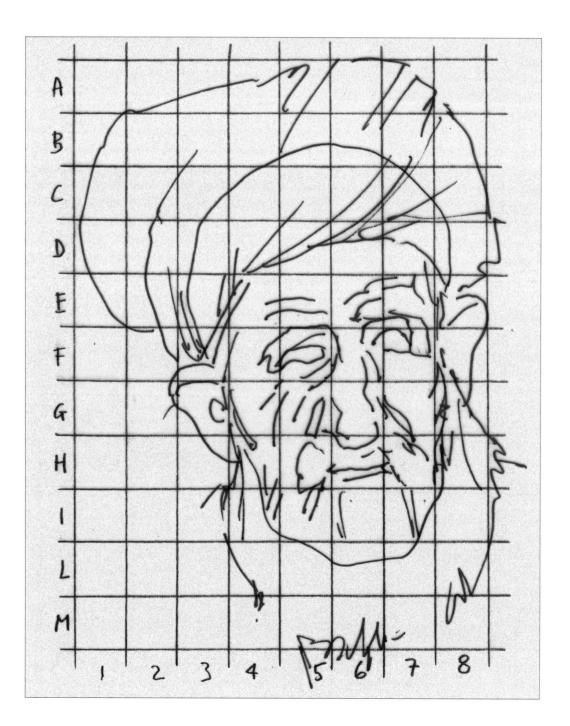

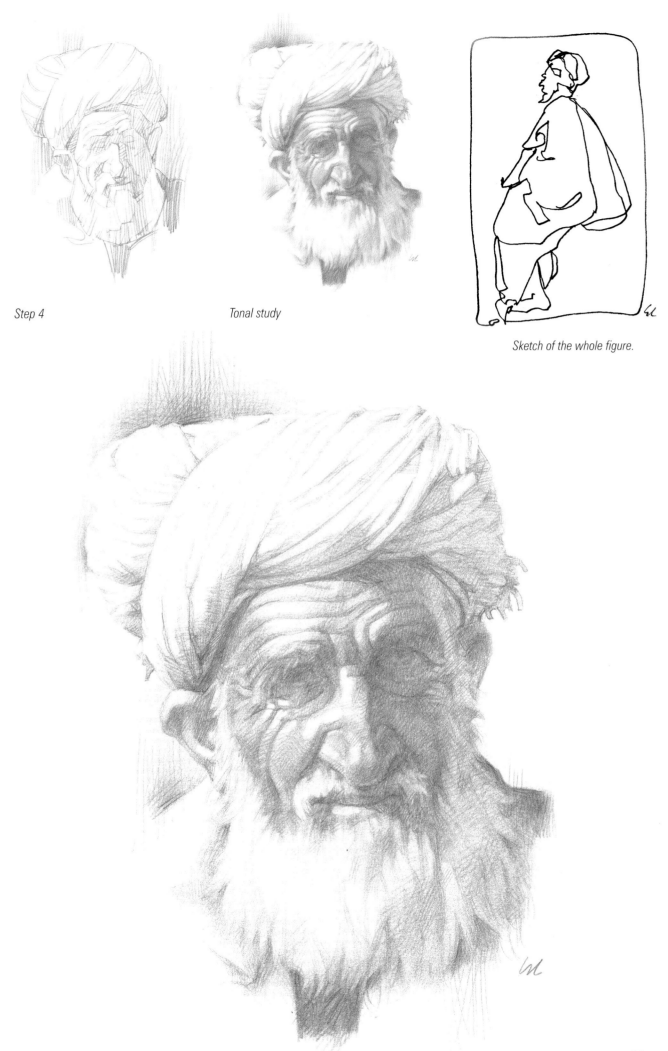

Step 4

Tonal study

Sketch of the whole figure.

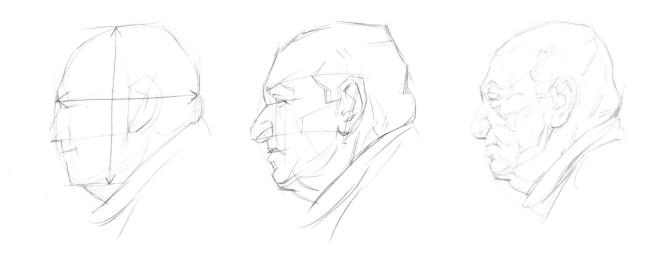

Step 1 Step 2 Step 3

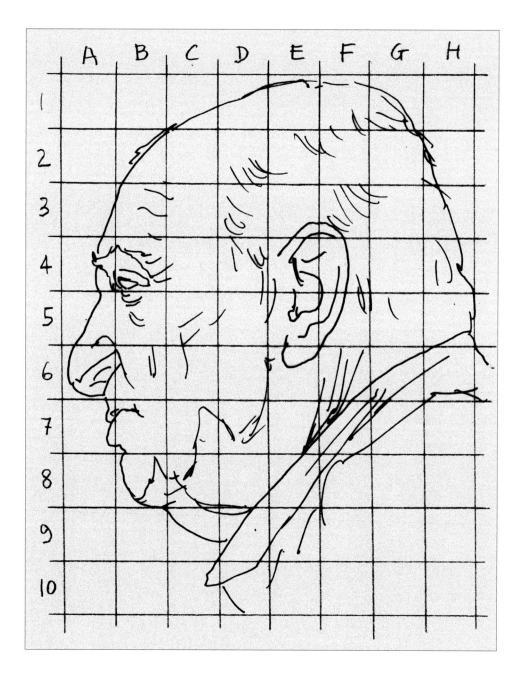

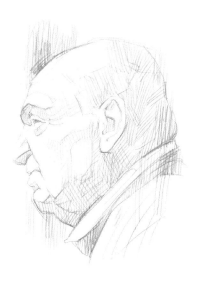

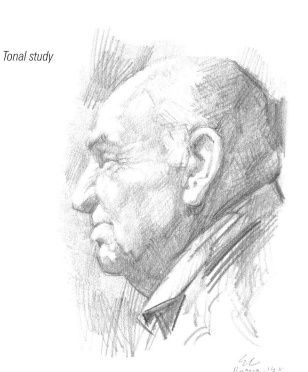

Tonal study

Step 4

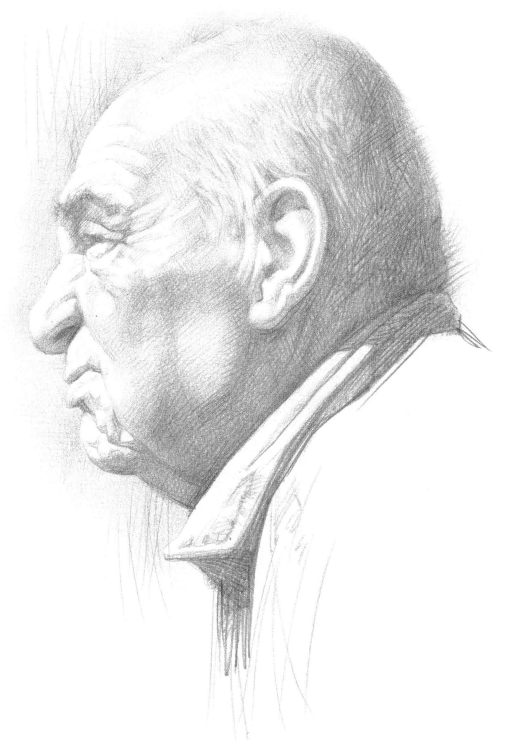

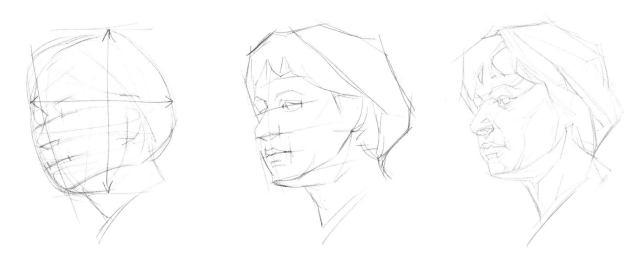

Step 1 *Step 2* *Step 3*

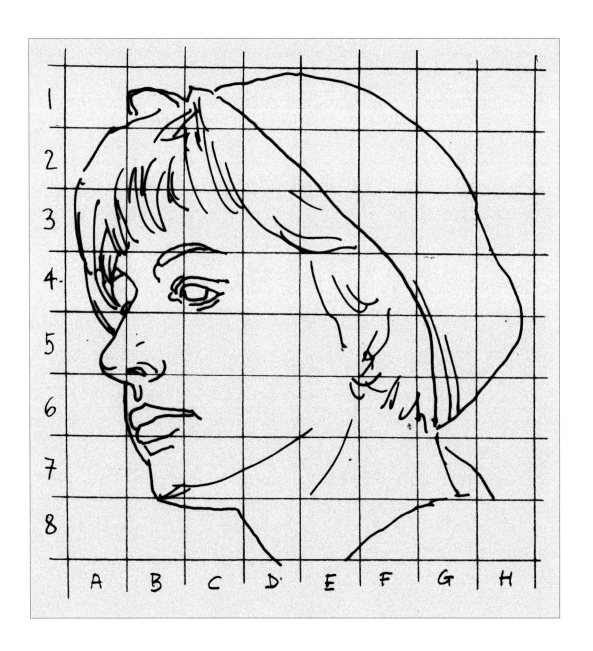

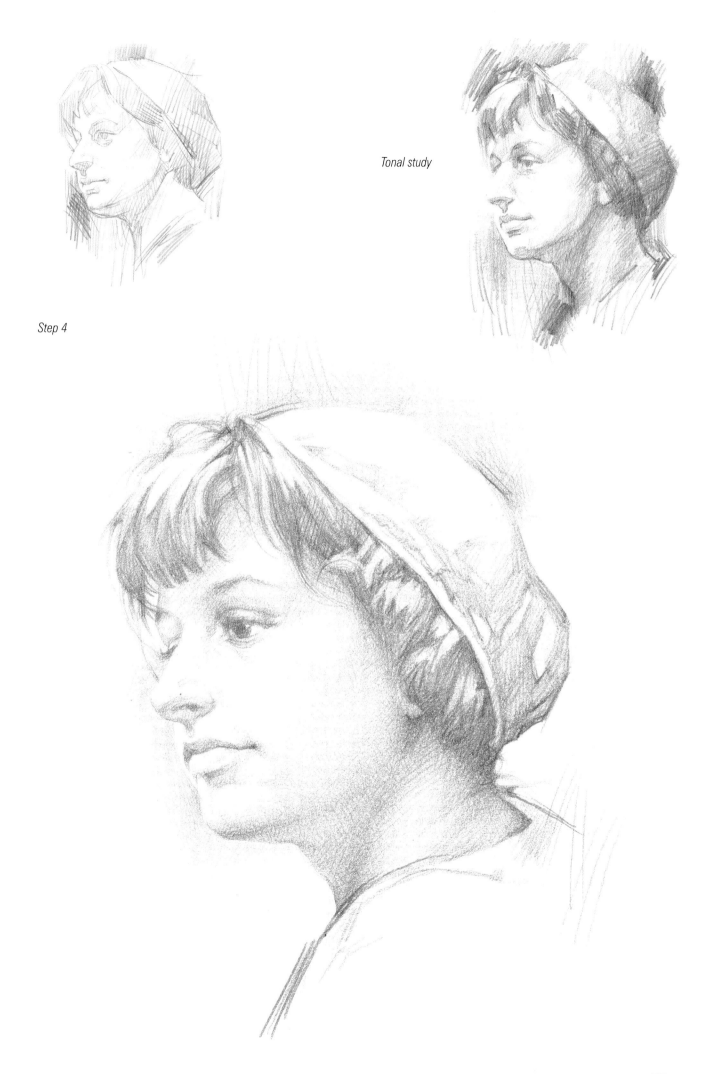

Tonal study

Step 4

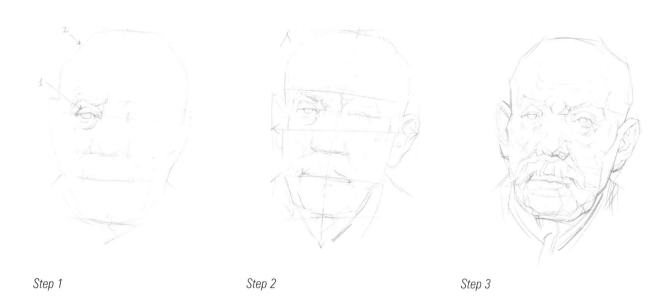

Step 1 *Step 2* *Step 3*

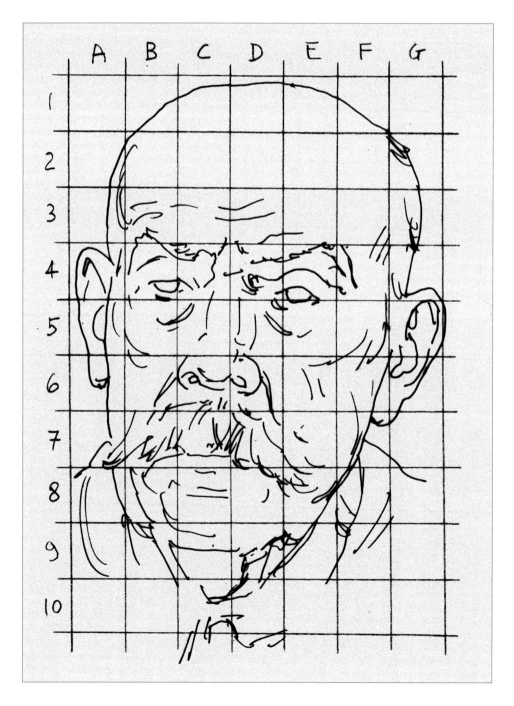

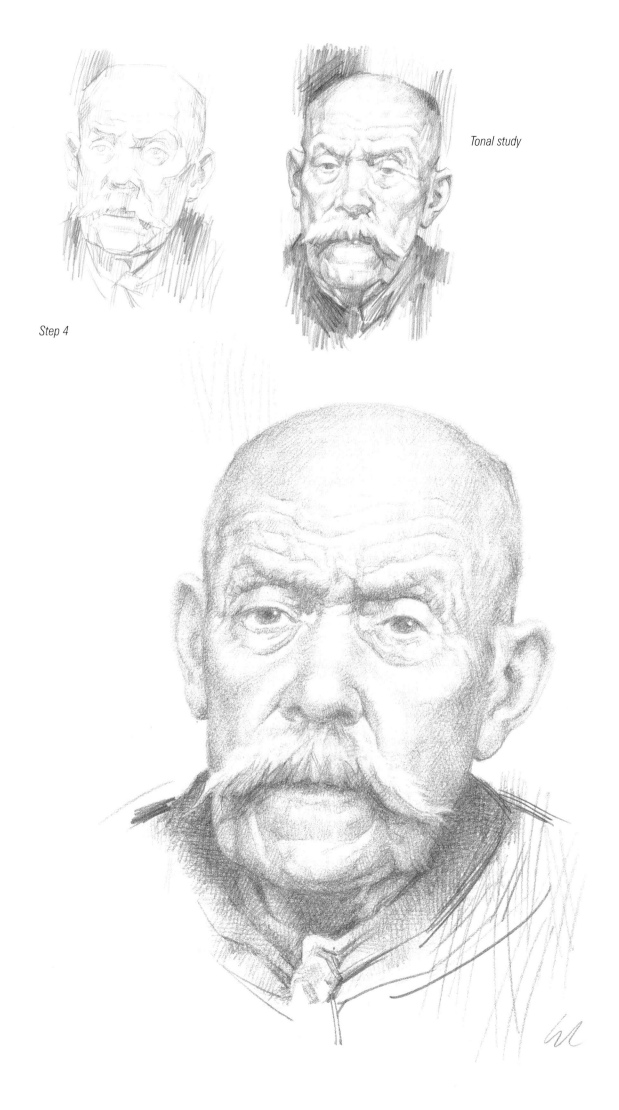

Tonal study

Step 4

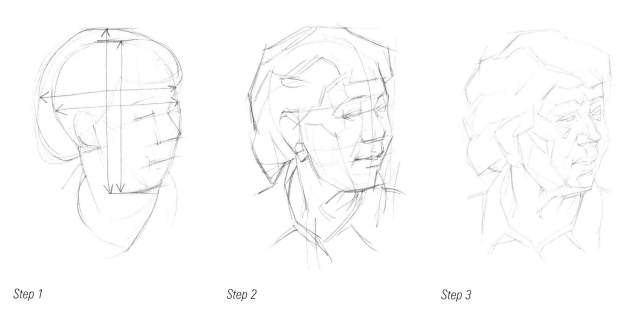

Step 1 *Step 2* *Step 3*

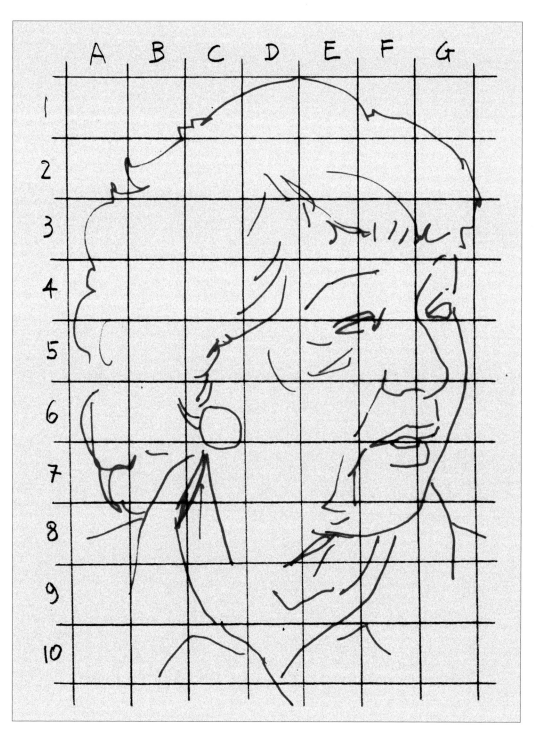

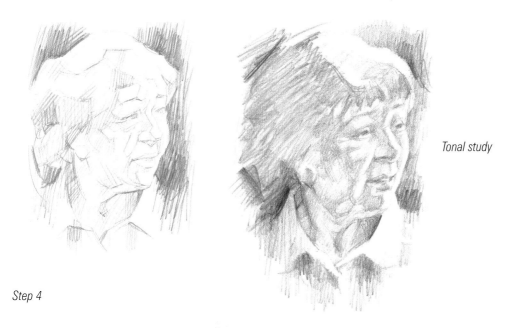

Tonal study

Step 4

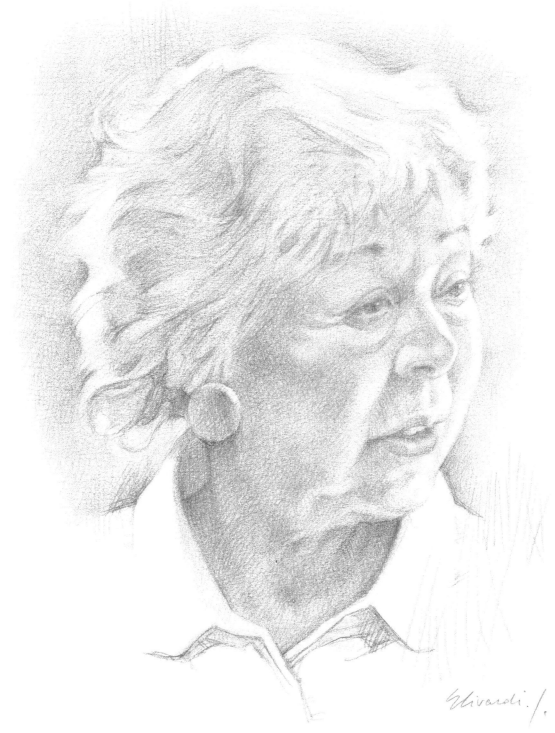

A useful exercise is to portray the same head using not just different techniques (as on pages 26–27), but also following different drawing procedures, to compare the results, as shown in the examples below.

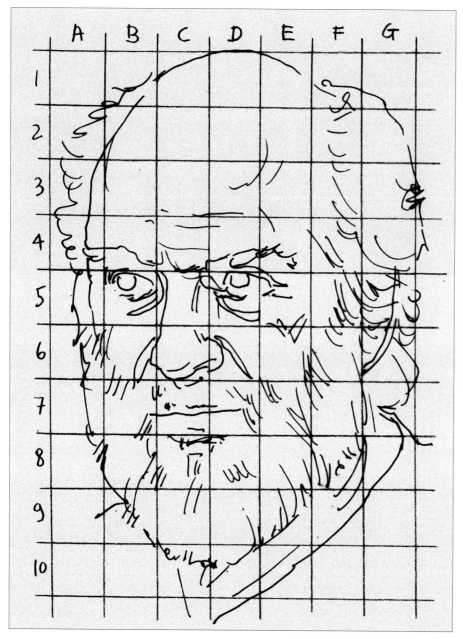

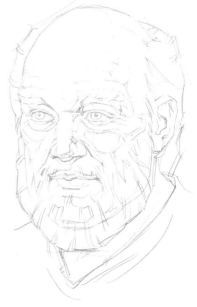

Here I traced the initial steps of a portrait drawing by following a structural procedure; that is, providing more emphasis on 'solid' elements that give volume and consistency to the head, pronouncing the shapes.

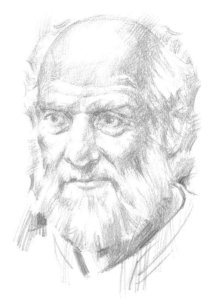

Here I have given preference to a procedure concentrated on tones of light and shade, that searches for the development of 'planes' described by the modulation in tone, while not neglecting the steadfastness of the shapes.

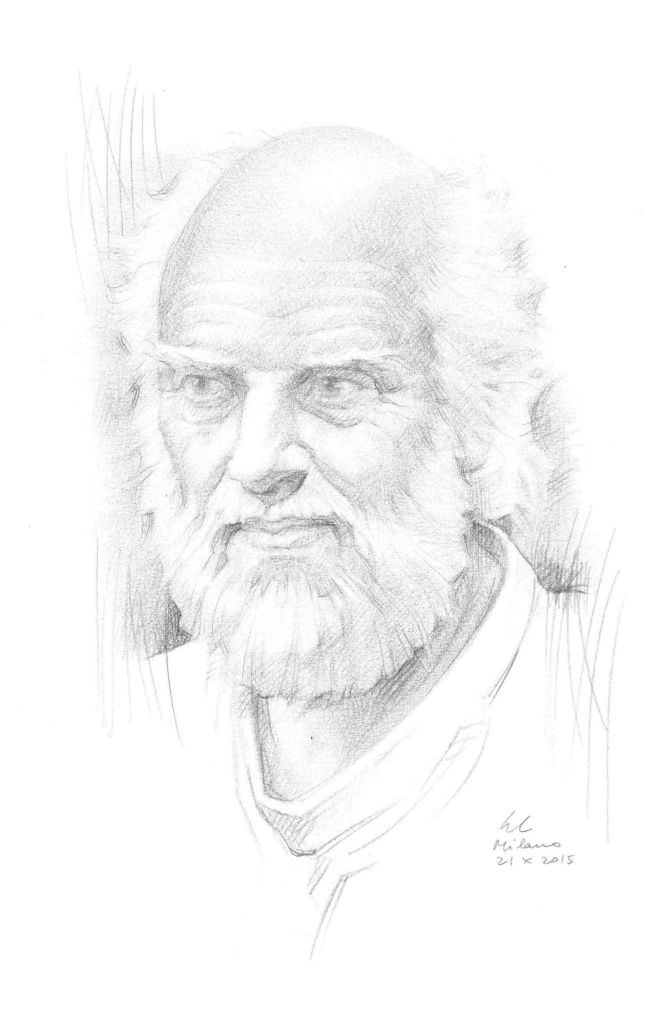

Milano
21 X 2015

41

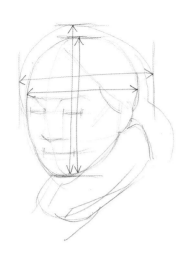

Step 1

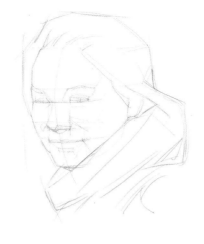

Step 2

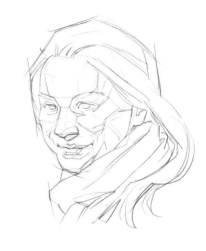

Step 3

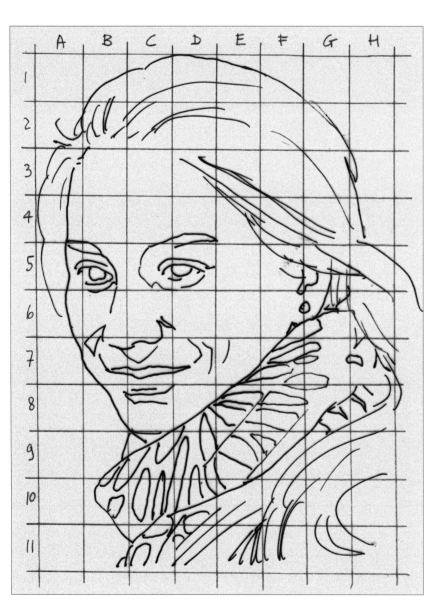

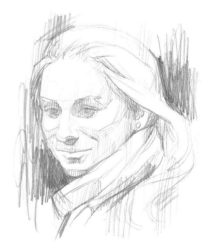

Step 4

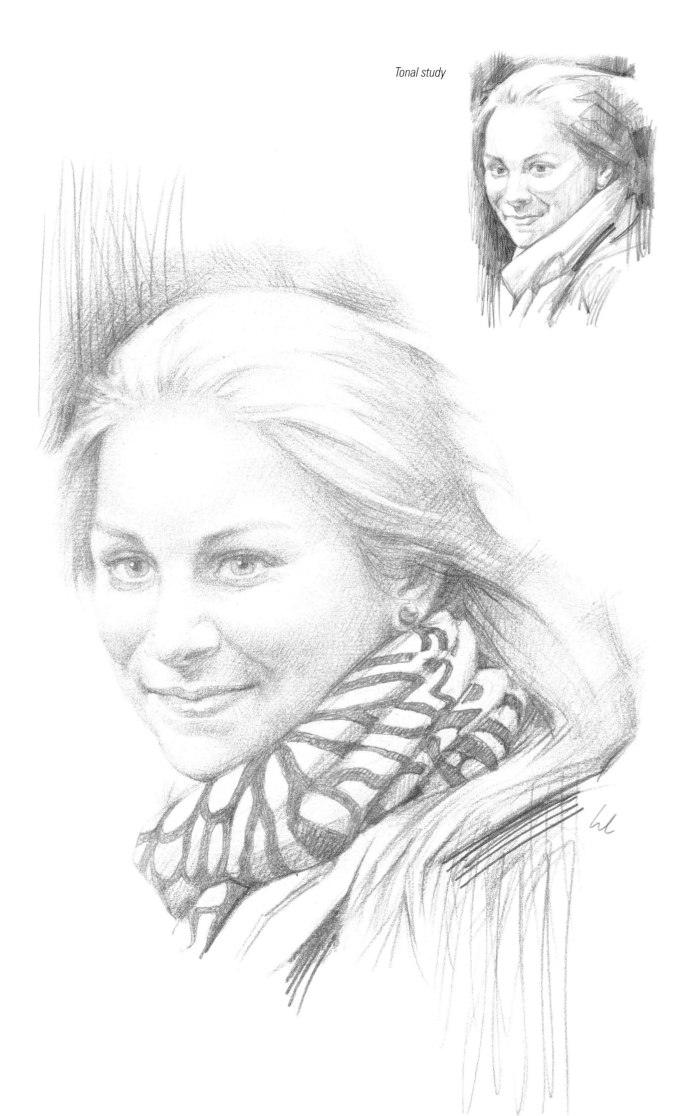

Tonal study

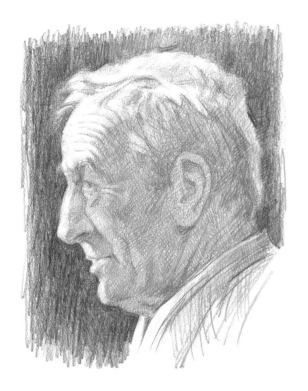

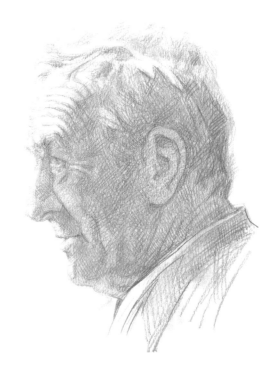

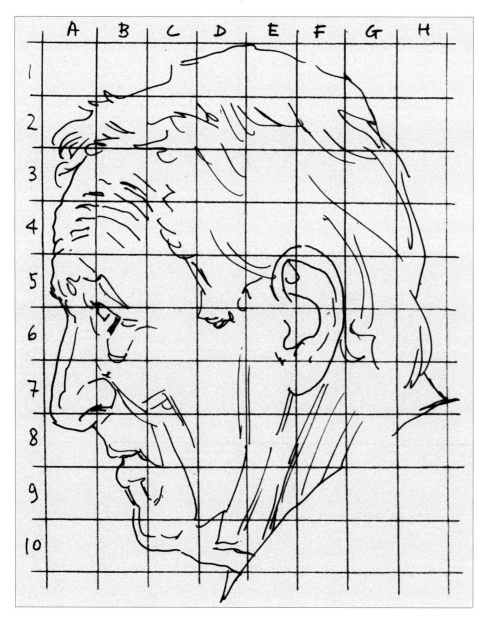

The face in the studies above uses the same tones of light and shade in both drawings, yet the result is rather different depending on whether the head is placed against a dark backdrop or a light one.

This effect is very important in artistic portrayal. The very dark background lends apparent luminosity to the tones in the part of the face in shade, that, in contrast, appears to be quite light. The illuminated part of the profile seems to be even lighter. On the other hand, the white background makes the same shading tones seem rather dark, while the illuminated part of the face seems faded and lost in the surroundings.

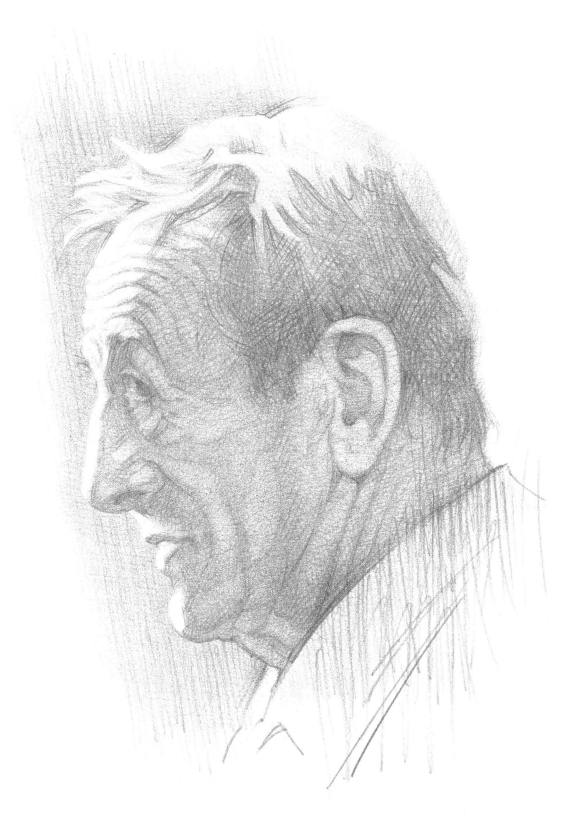

The drawing on this page, which is more elaborate than the two preceding studies, has lost a little simplicity and expressive spontaneity, but shows an improved, more balanced distribution of tonal hues that are mostly harmonised by a medium-intensity background.

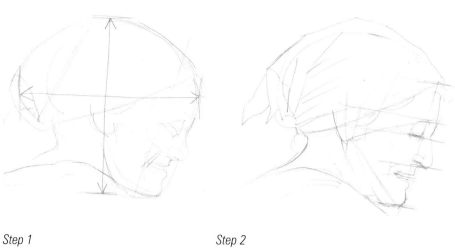

Step 1

Step 2

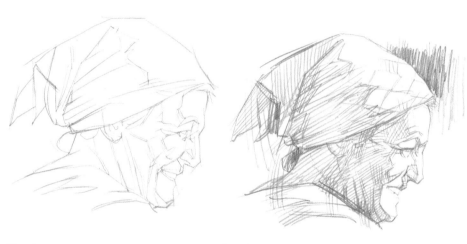

Step 3

Step 4

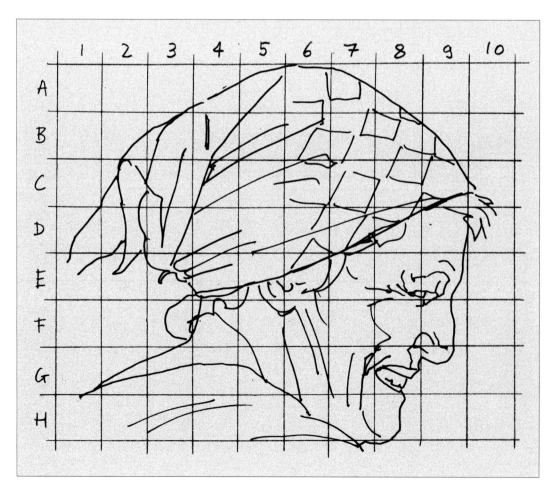

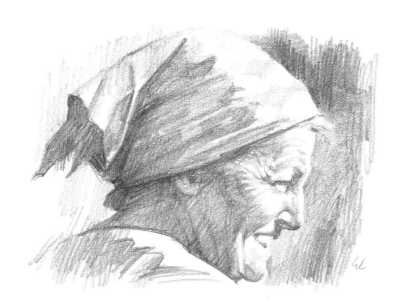

Tonal study

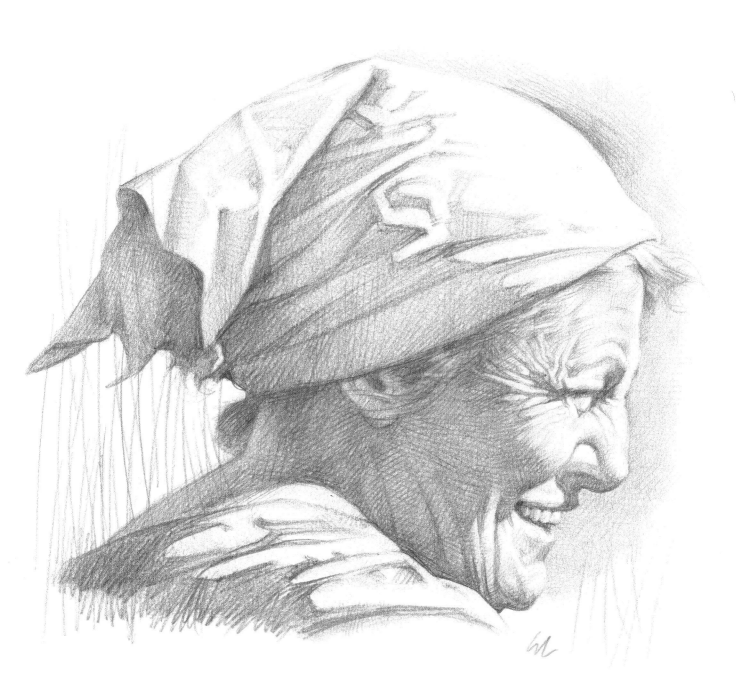

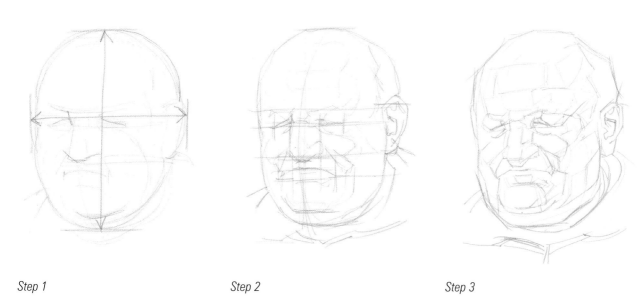

Step 1 *Step 2* *Step 3*

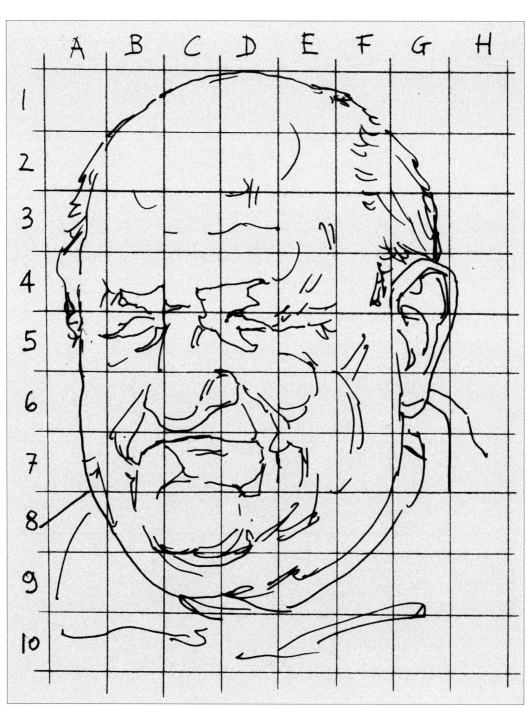

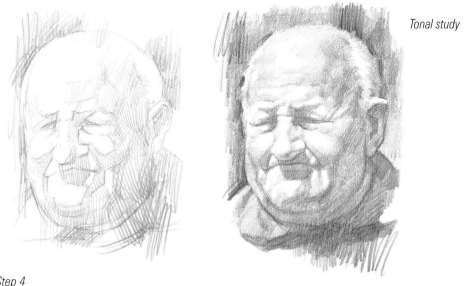

Tonal study

Step 4

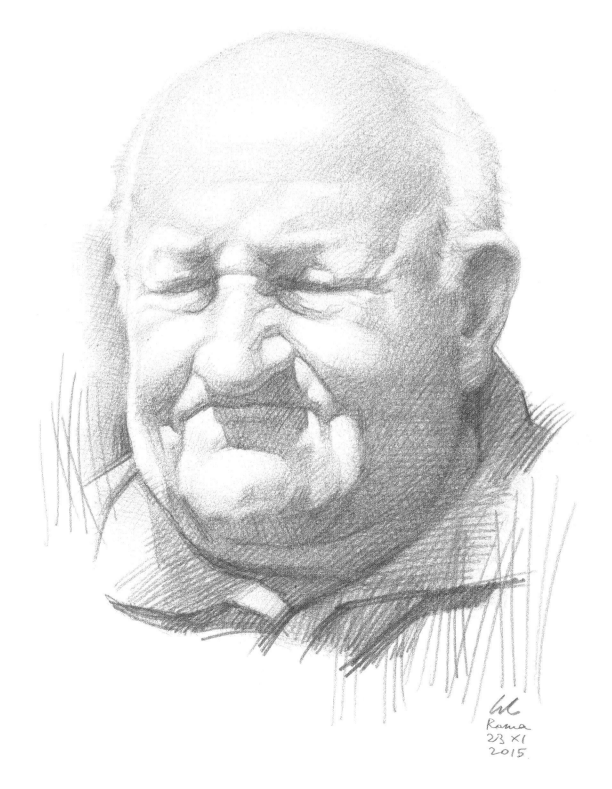

Roma
23 XI
2015

49

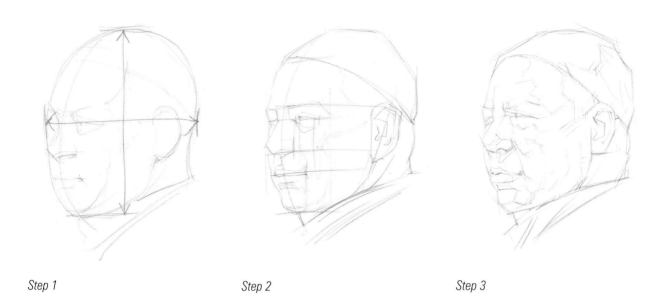

Step 1 *Step 2* *Step 3*

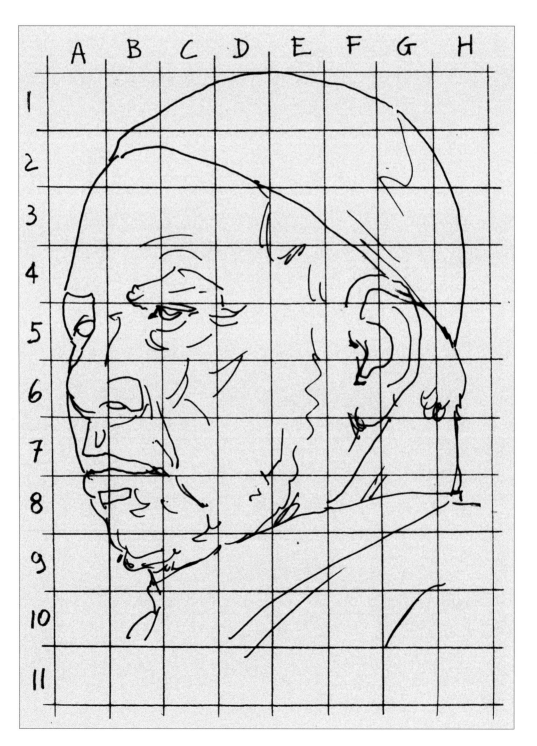

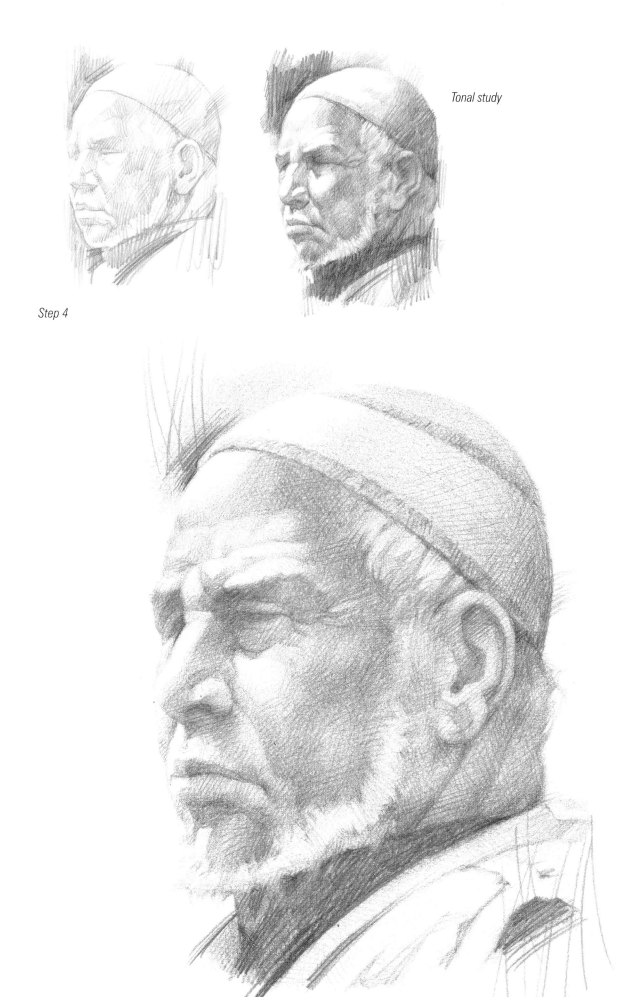

Step 4

Tonal study

51

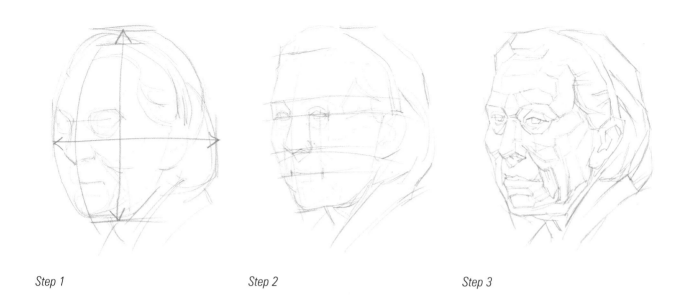

Step 1 *Step 2* *Step 3*

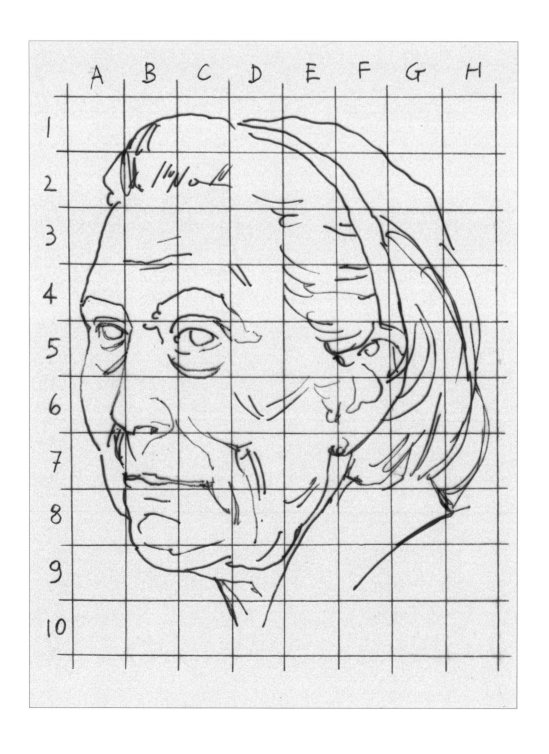

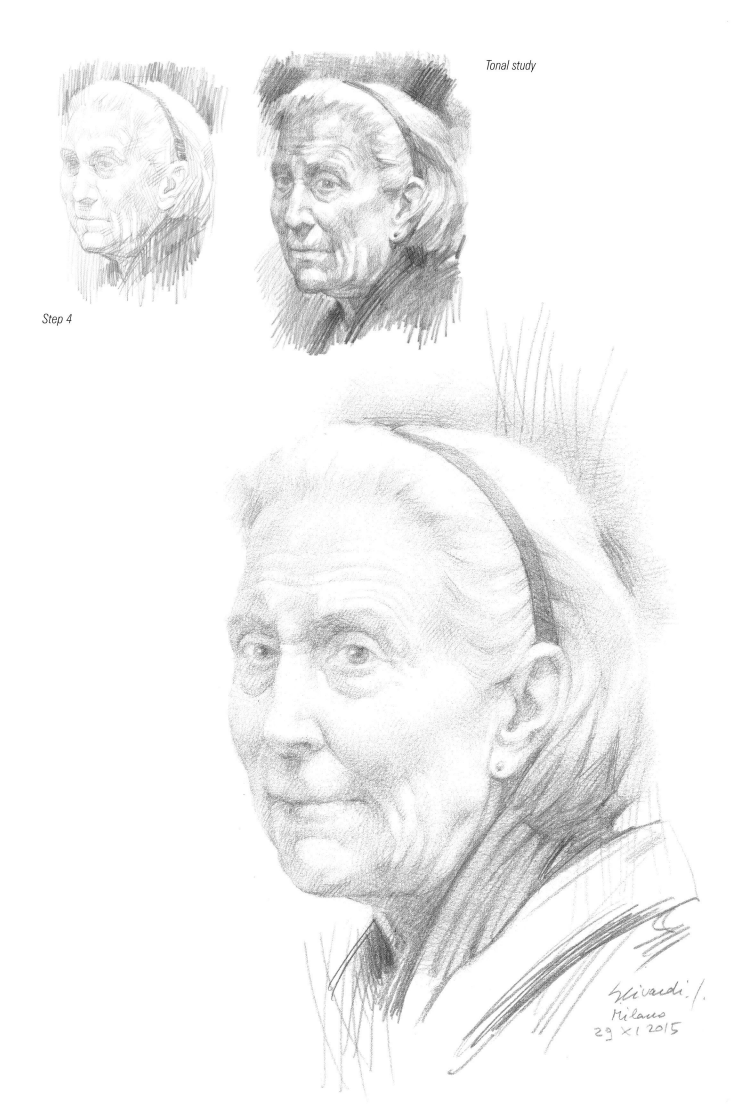

Tonal study

Step 4

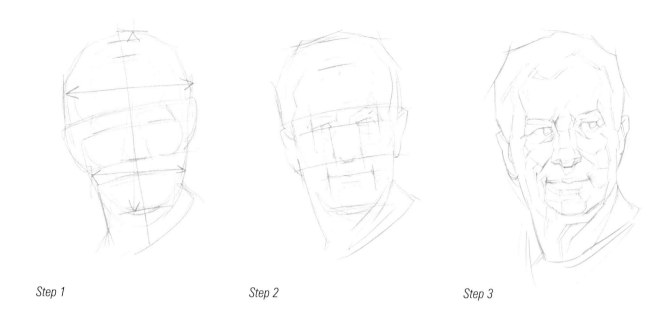

Step 1 Step 2 Step 3

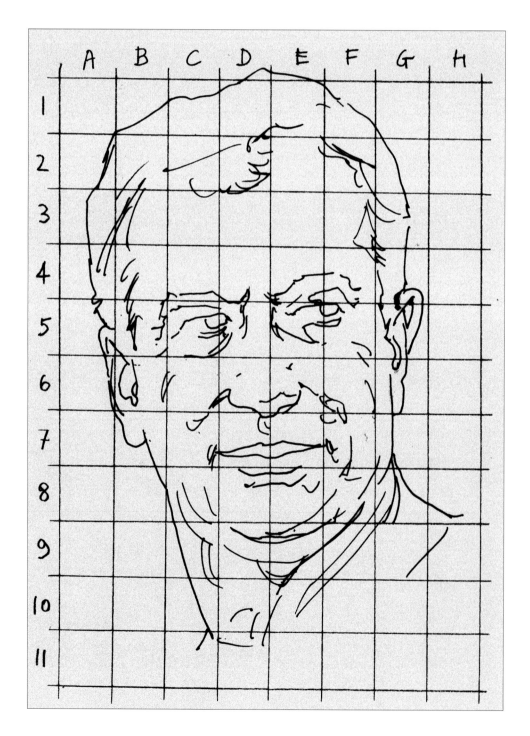

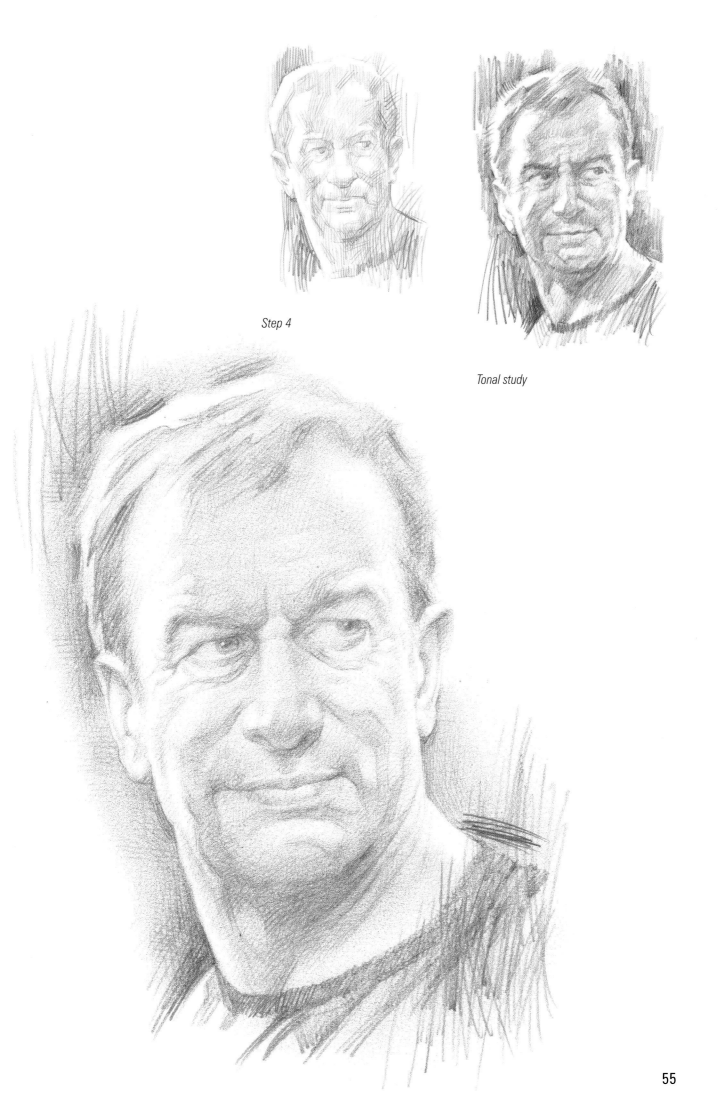

Step 4

Tonal study

55

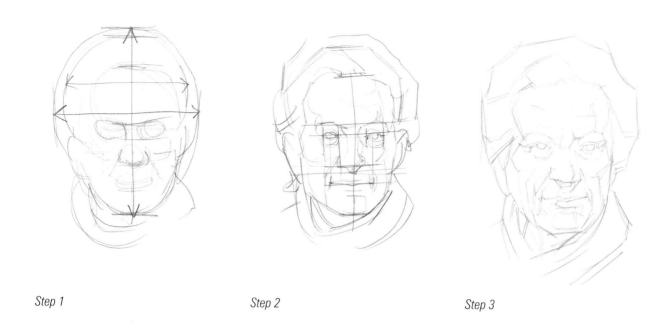

Step 1 *Step 2* *Step 3*

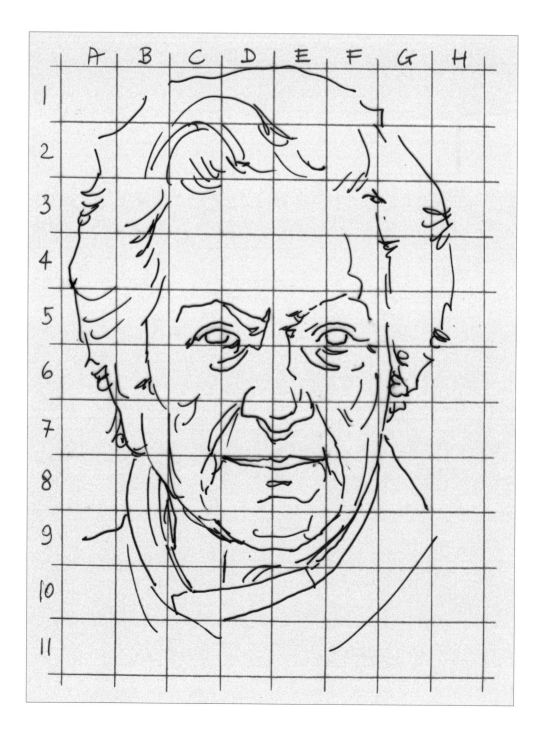

56

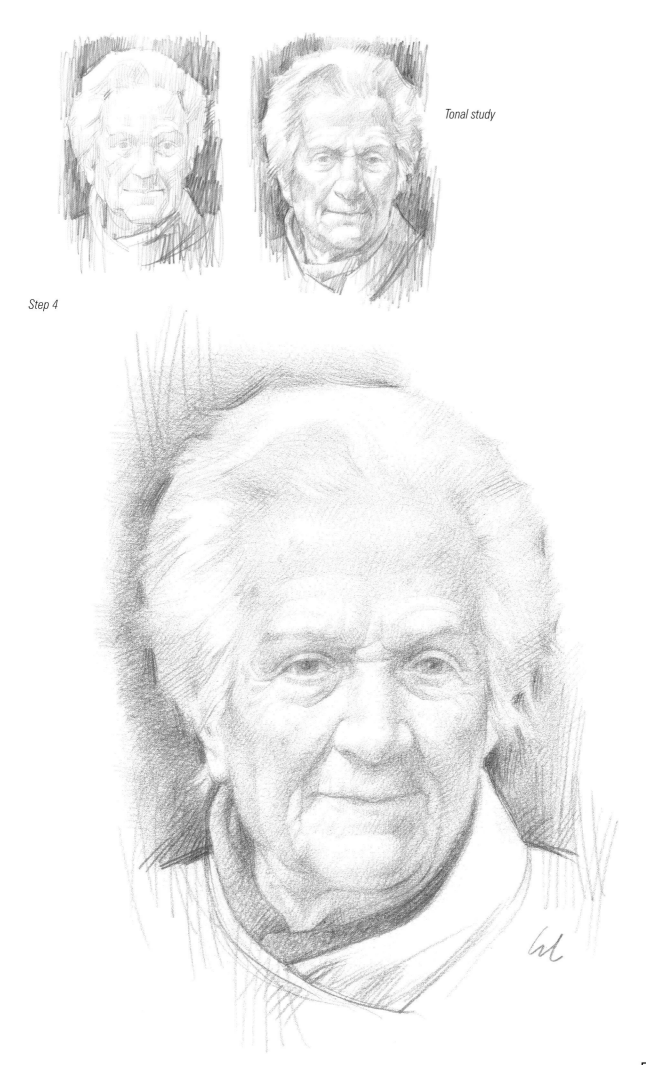

Tonal study

Step 4

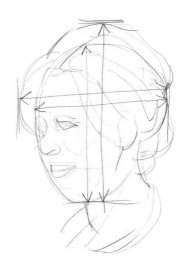

Step 1

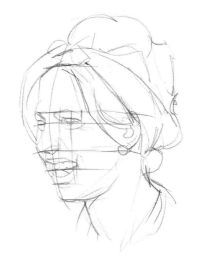

Step 2

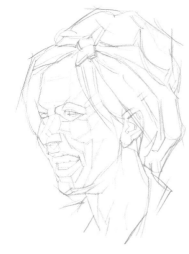

Step 3

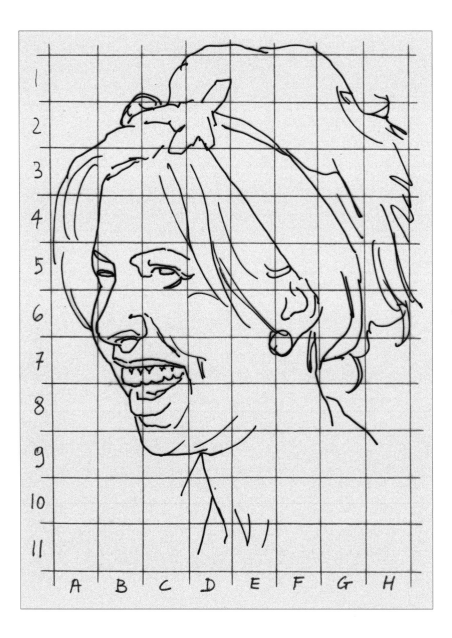

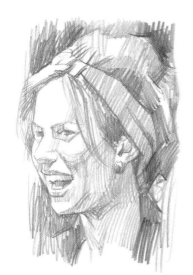

Step 4

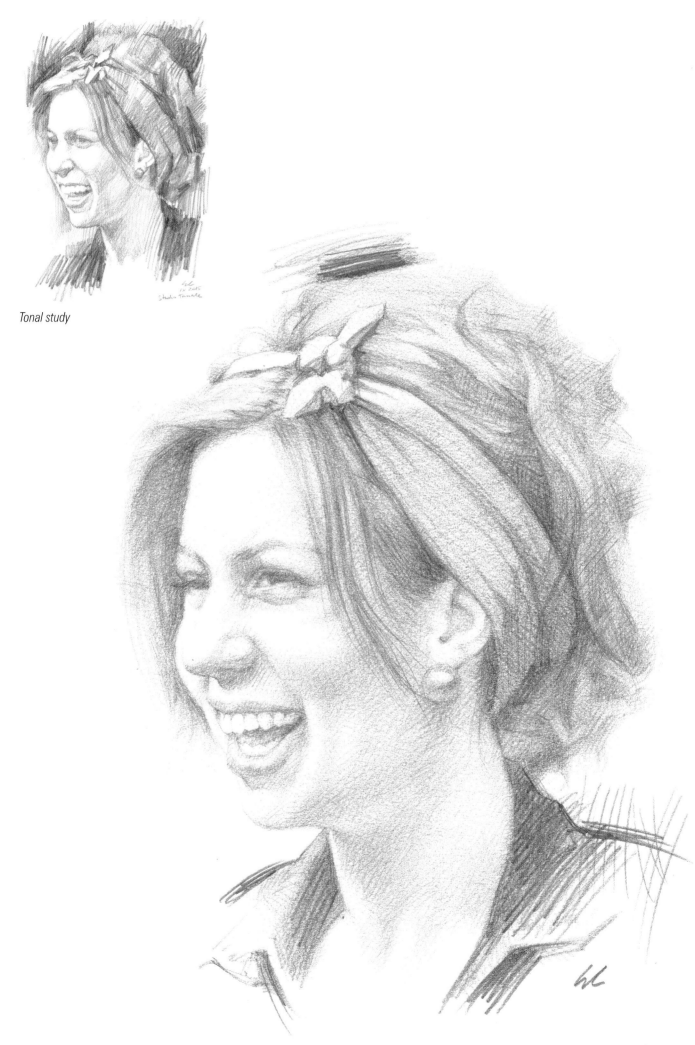

Tonal study

59

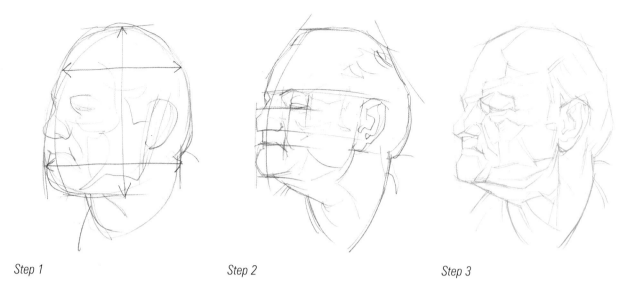

Step 1 *Step 2* *Step 3*

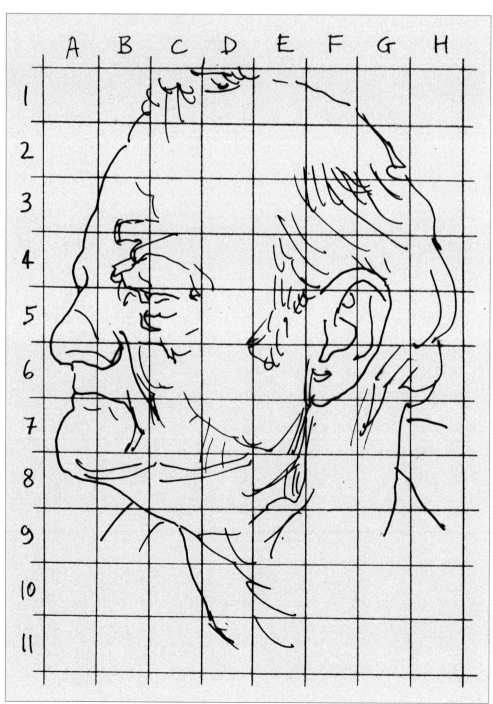

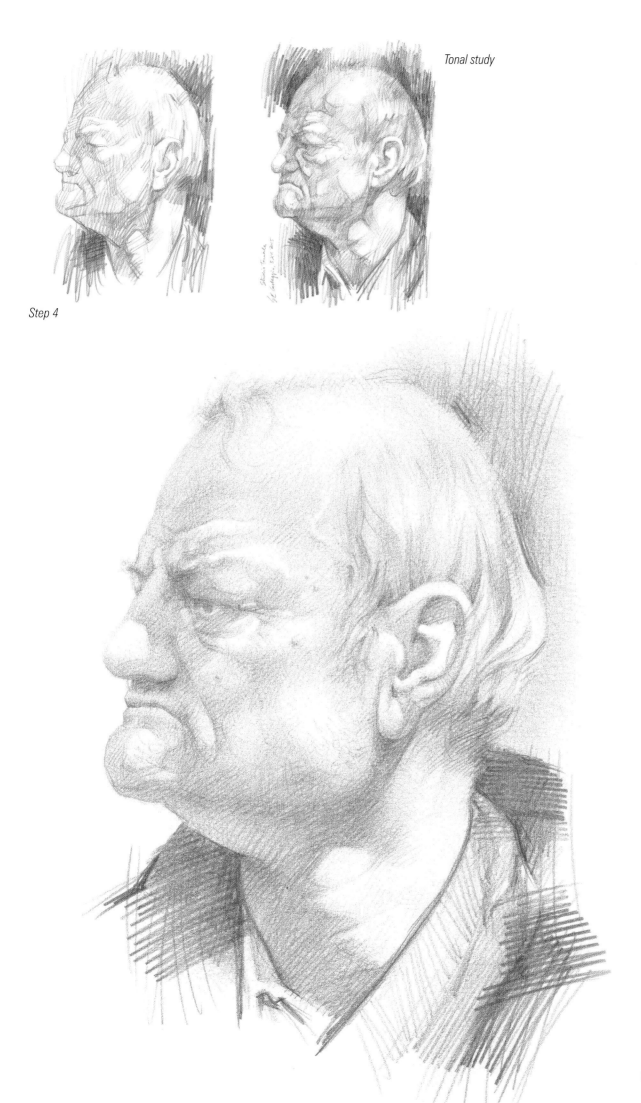

Tonal study

Step 4

61

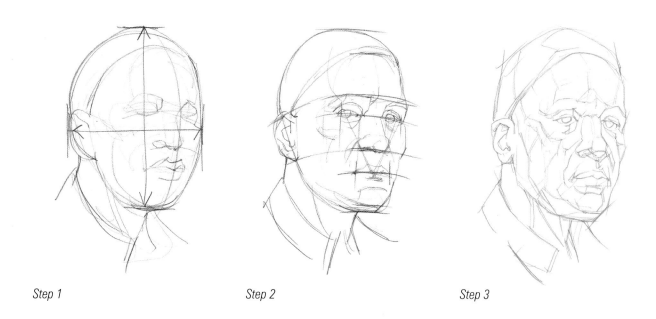

Step 1 Step 2 Step 3

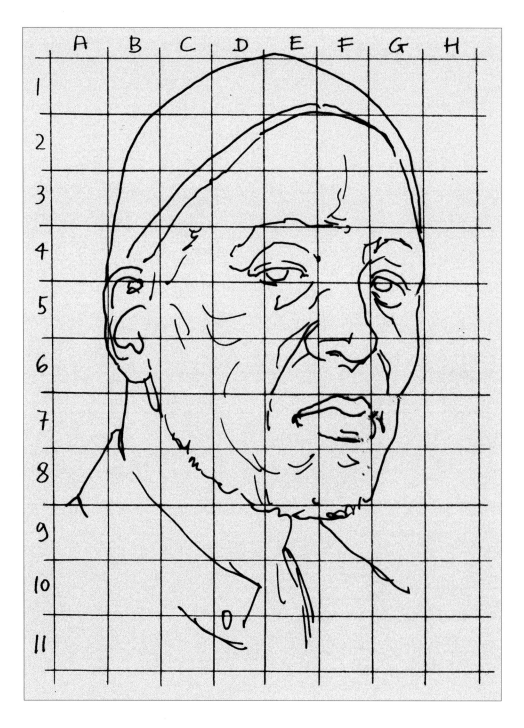

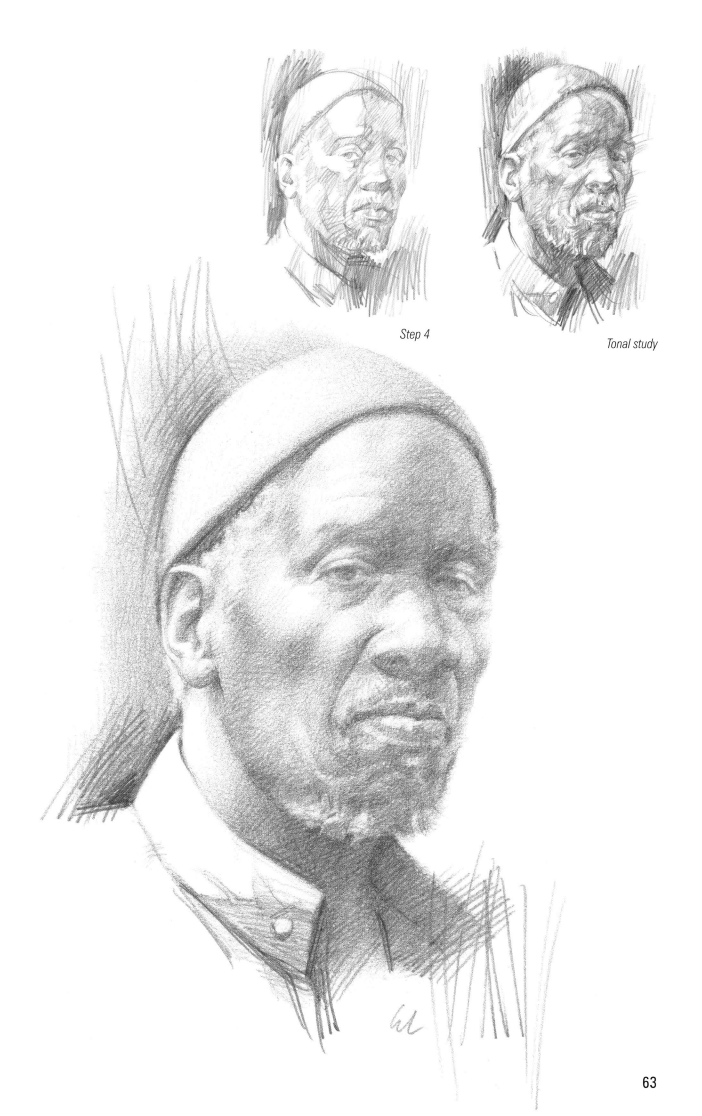

Step 4

Tonal study

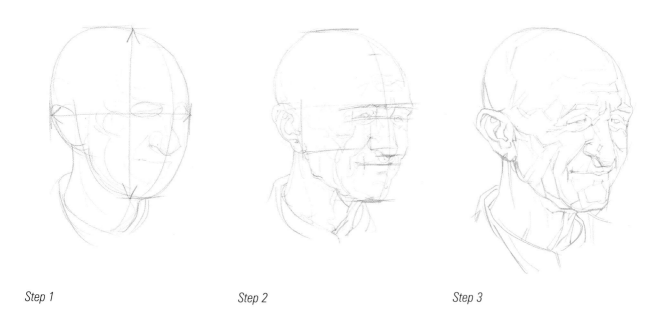

Step 1 Step 2 Step 3

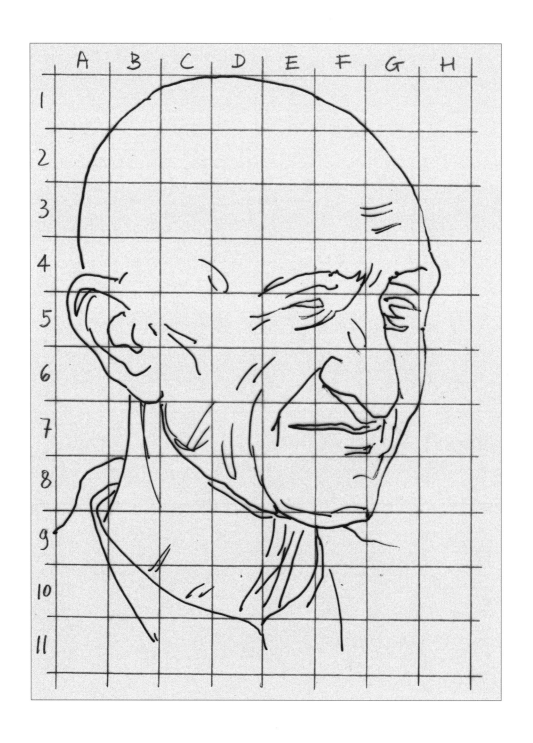

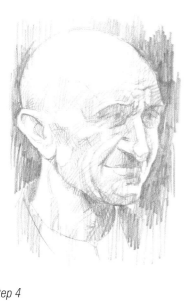

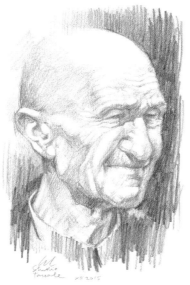

Tonal study

Step 4

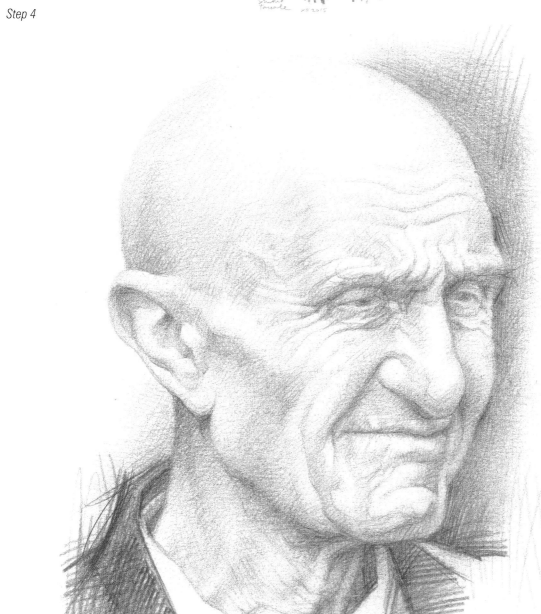

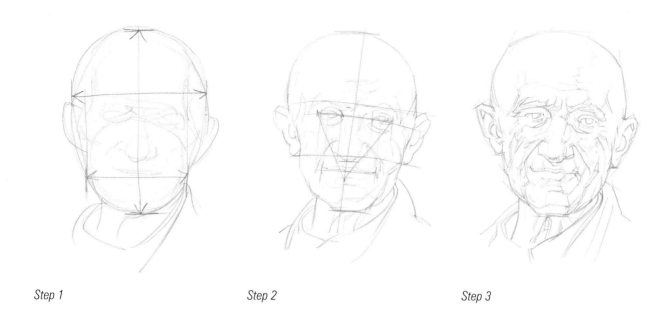

Step 1 *Step 2* *Step 3*

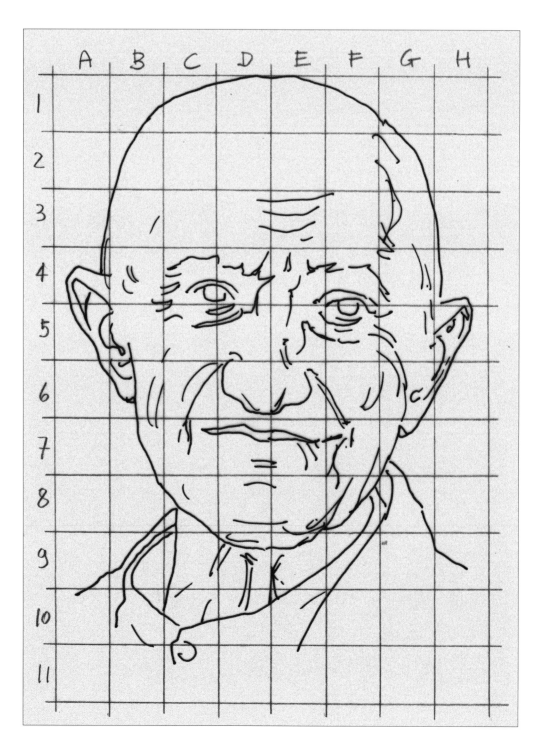

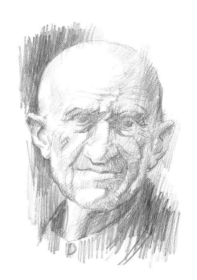

Step 4

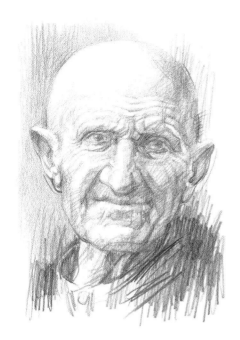

Tonal study

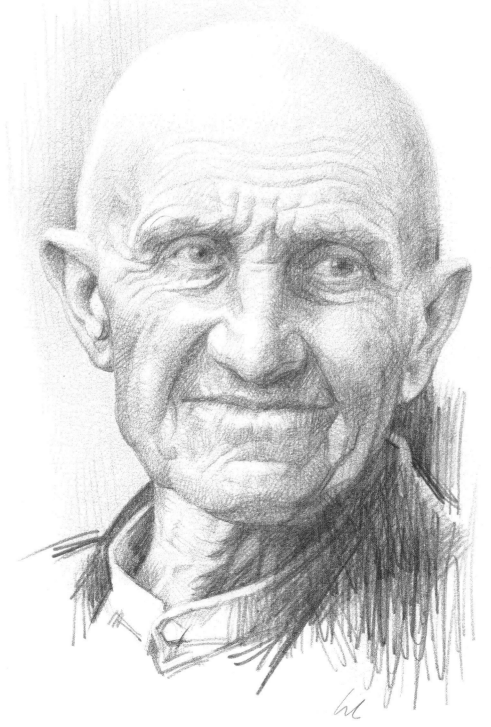

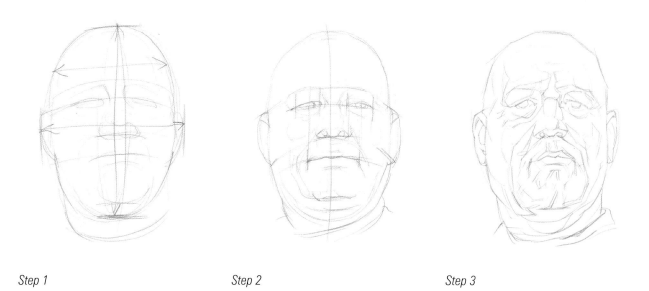

Step 1 Step 2 Step 3

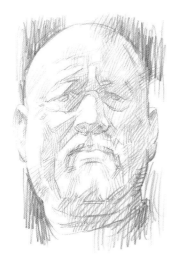

Step 4

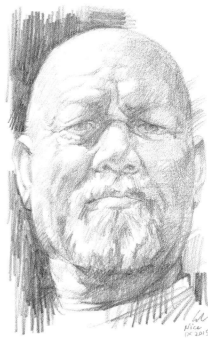

Tonal study

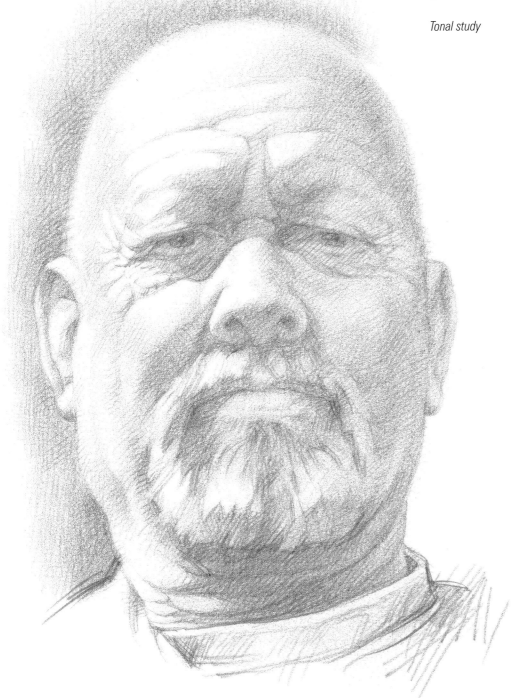

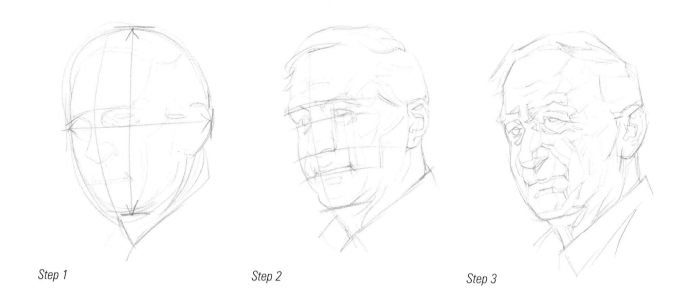

Step 1 Step 2 Step 3

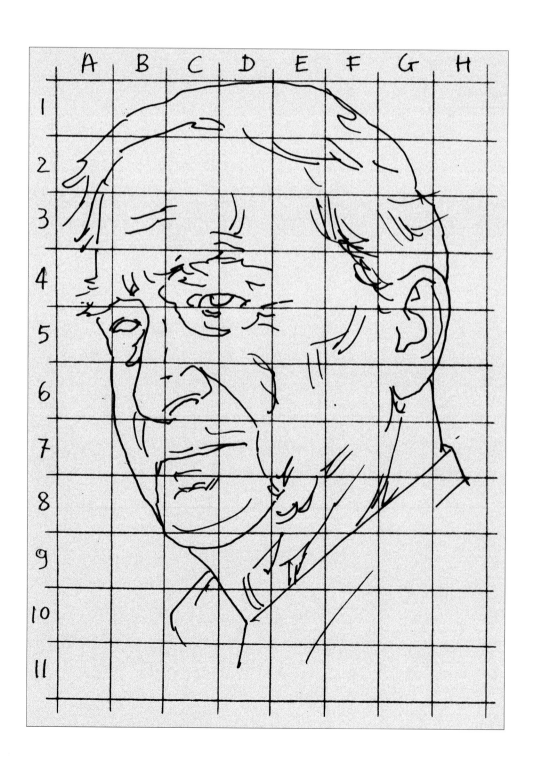

70

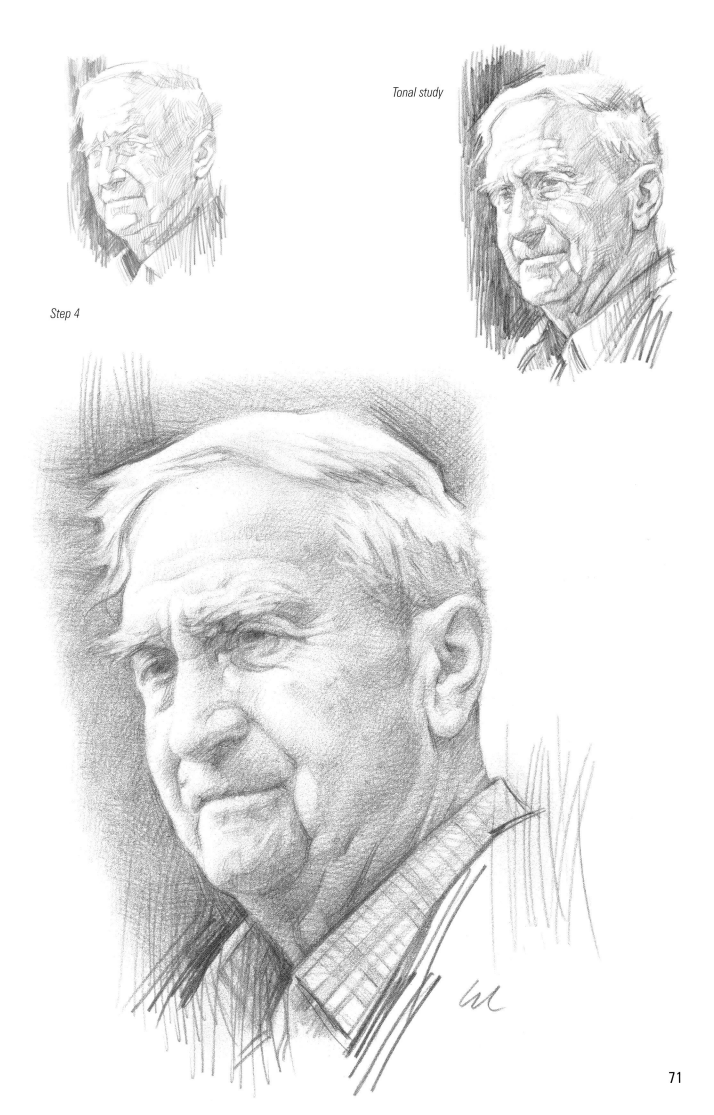

Tonal study

Step 4

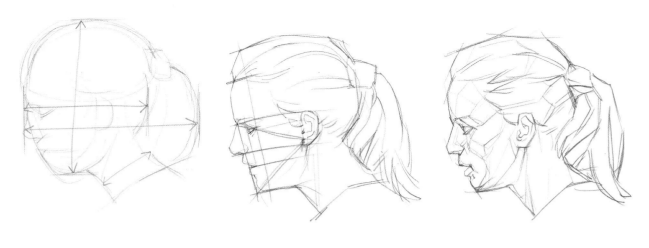

Step 1 Step 2 Step 3

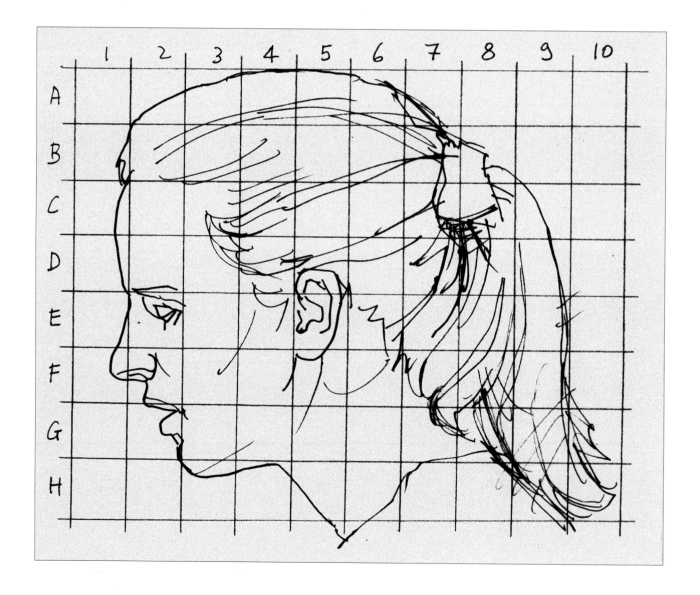

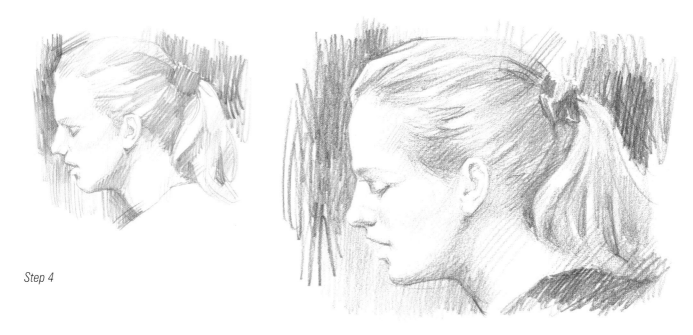

Step 4

Tonal study

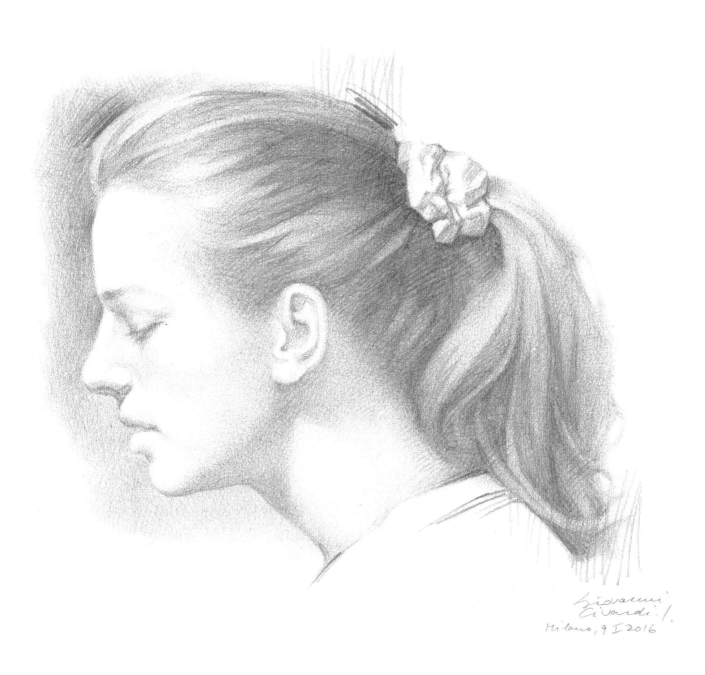

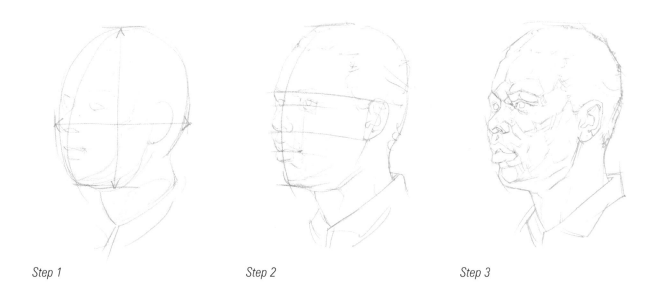

Step 1 Step 2 Step 3

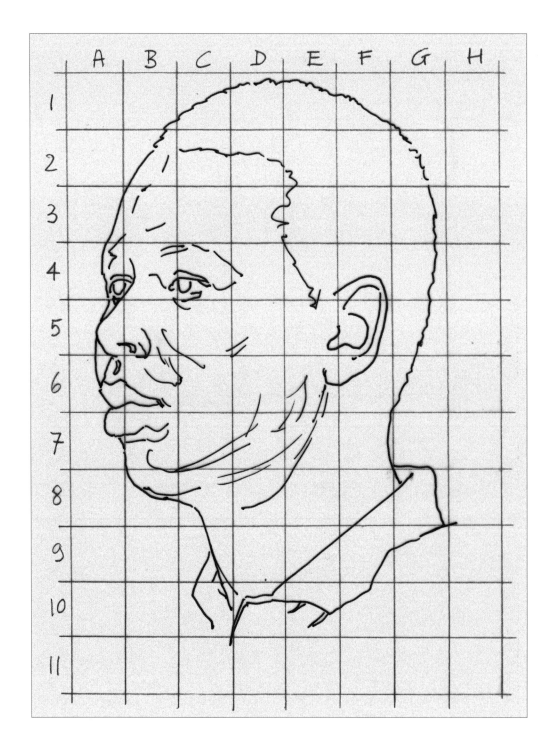

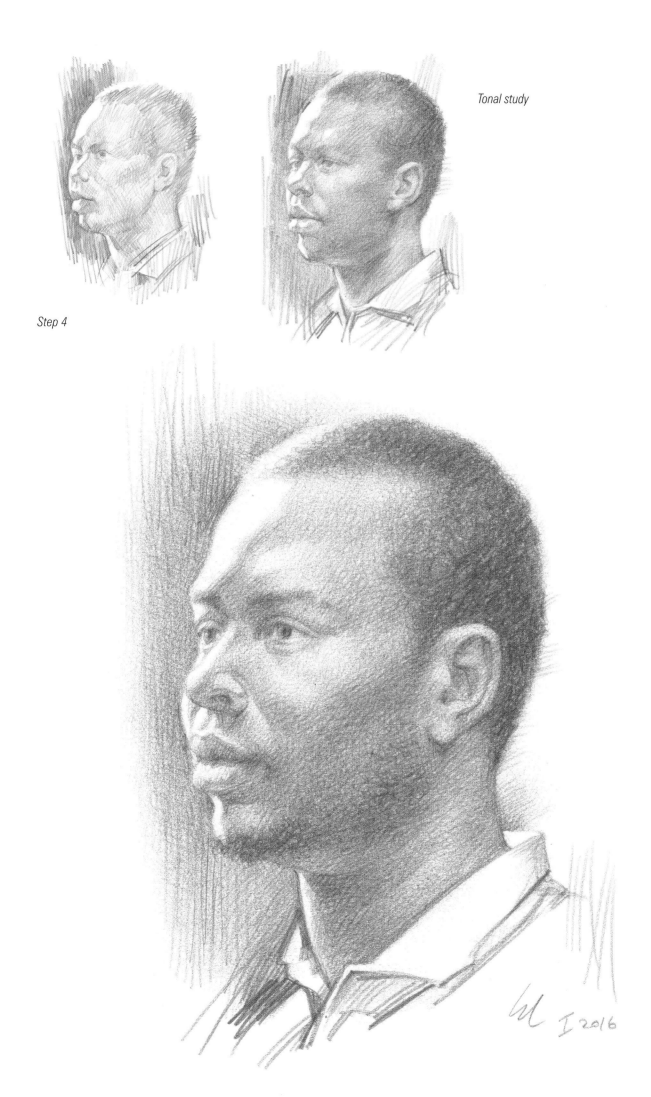

Tonal study

Step 4

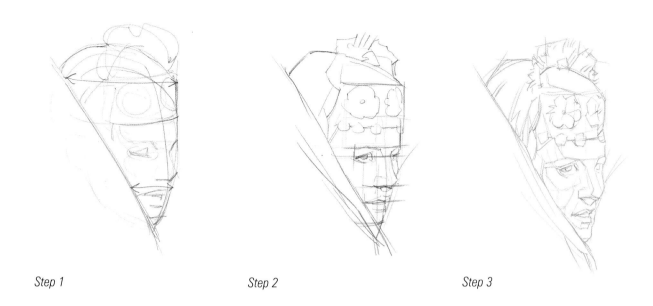

Step 1 Step 2 Step 3

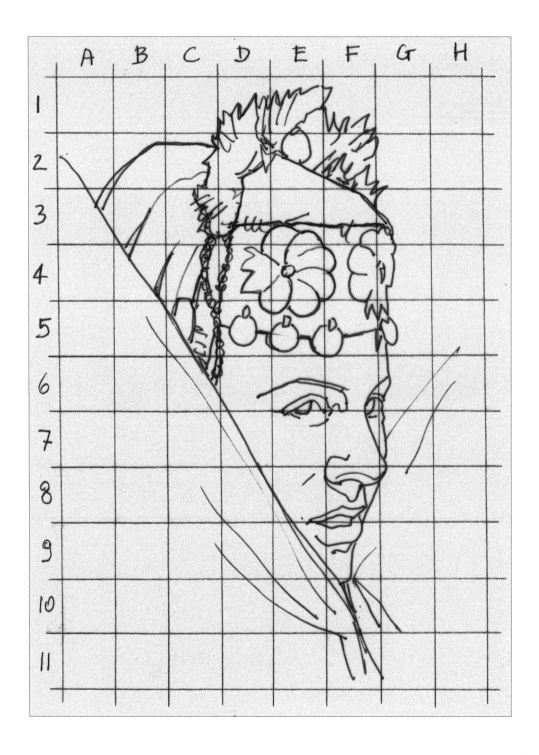

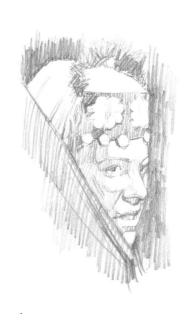

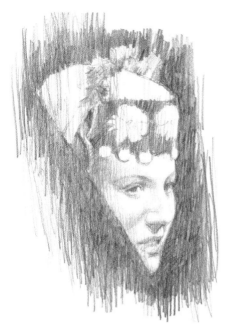

Tonal study

Step 4

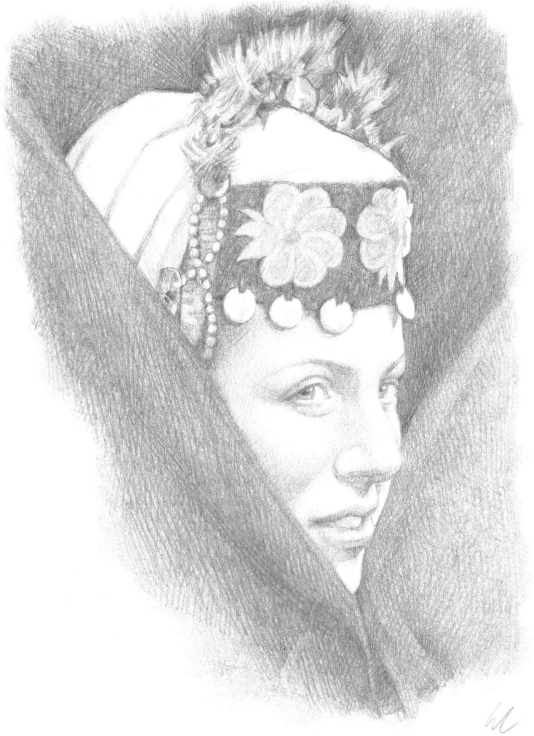

Finding inspiration

The face is the most important part of the body for recognising and identifying a person, and attracts us from early months of life as a fundamental visual element. In fact, some areas of the brain seem to be geared to immediately recognising human faces and bodies; this is due to evolution, perhaps connected with the need to survive.

The tendency to recognise known shapes in vague, random shapes and therefore to see general likenesses of faces, heads and profiles emerge from chance associations of marks or spots is a common one. The spots can be drips of colour, splashes of mud or ink, or simply accidental arrangements such as spots of rust or mould, cracks in walls, clouds, veins in stone and so forth. Such chance encounters have been seen by artists in both the East and the West throughout history, who often found beauty and inspiration in them for their most elaborate works. In these marks, everyone can see what their psychological state, existential experiences, subconscious visual culture or emotions allow them to see: frequently, what is 'seen' is connected to human or animal faces.

Concentrating on these random observations, or even looking for them deliberately, can be a good exercise for increasing visual stimulation in a process for your imagination. Such subconscious suggestion, in a kind of free association, can lead to the most expressive, curious or grotesque faces that are – almost by definition – characterful.

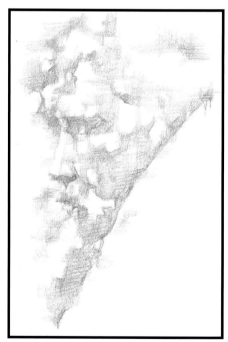

These final three pages show some images taken from the study notebook that I always keep with me: the richest source of attraction and stimulation are the cracks and veins in marble that can almost always be found in old churches and monumental buildings.

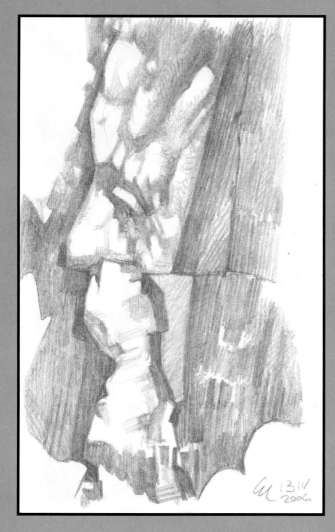

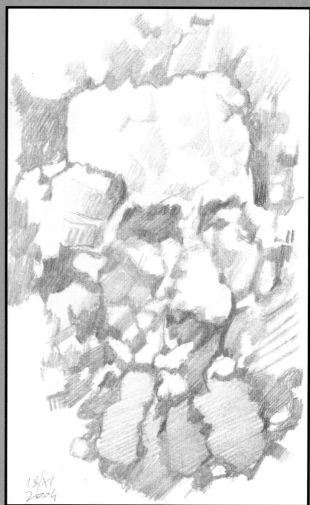

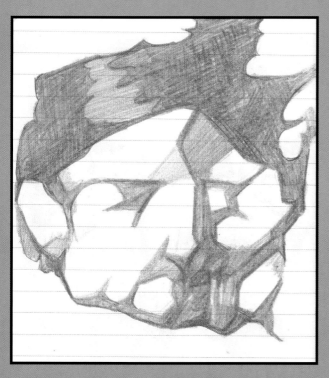

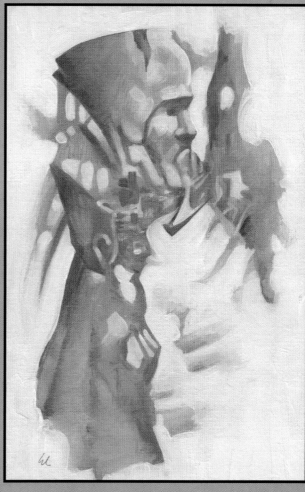

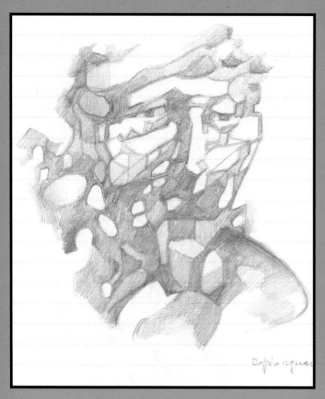

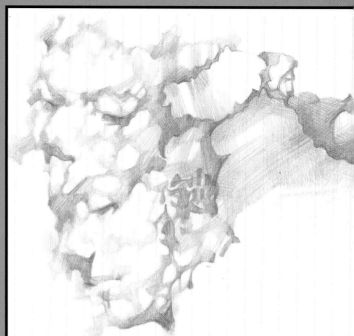

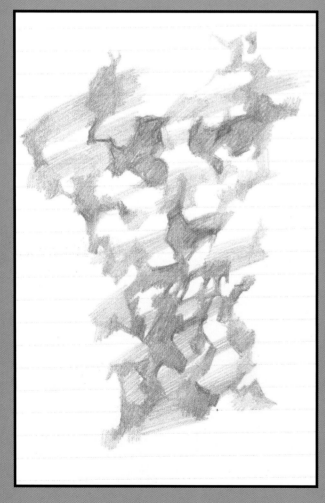

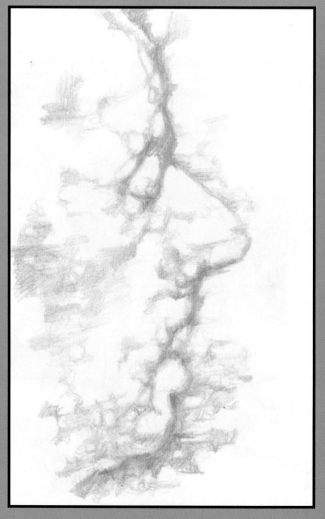